M000159997

IMAGES
of America

MEMPHIS MUSIC
BEFORE THE BLUES

Tim Sharp

ARCADIA
PUBLISHING

Copyright © 2007 by Tim Sharp
ISBN 978-0-7385-4411-3

Published by Arcadia Publishing
Charleston, South Carolina

Printed in the United States of America

Library of Congress Catalog Card Number: 2006937179

For all general information contact Arcadia Publishing at:
Telephone 843-853-2070
Fax 843-853-0044
E-mail sales@arcadiapublishing.com
For customer service and orders:
Toll-Free 1-888-313-2665

Visit us on the Internet at www.arcadiapublishing.com

*To the Memphis Symphony Orchestra, Opera Memphis, Rudi E. Scheidt School of Music
at the University of Memphis, Department of Music at Rhodes College, Memphis Chamber
Music Society, Beethoven Club, Rhodes MasterSingers Chorale, Rhodes Singers,
Memphis Boys Choir, Theatre Memphis, Playhouse on the Square, Orpheum Theatre,
Buckman Performing and Fine Arts Center, Concerts International,
Germantown Performing Arts Centre, Cannon Center for the Performing Arts,
Germantown Performing Arts Center, Ballet Memphis, members of the Memphis Players
Union Local Number 71, and the church and civic choral and instrumental organizations of
Memphis who together make Memphis a musical place to live.*

IMAGES
of America

MEMPHIS MUSIC
BEFORE THE BLUES

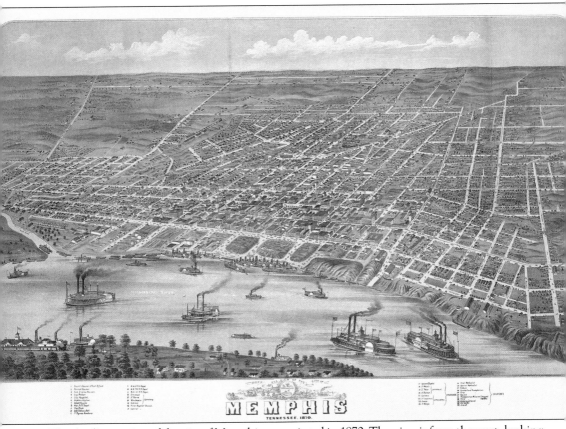

This bird's-eye view of the city of Memphis was printed in 1870. The view is from the west, looking back east across the Mississippi River and the active river traffic coming and going from the growing port city. The Wolf River is visible to the left, as is the urban street layout of the city.

ON THE COVER: Gasper Pappalardo and the Hotel Gayoso Orchestra was one of many small bands that populated Memphis before and after the blues came to town. The Gayoso House became a landmark of Memphis luxury. (Courtesy of Memphis Players Union Local No. 71.)

CONTENTS

ACKNOWLEDGMENTS

Images used are from the Memphis and Shelby County Room of the Memphis Public Library, the Beethoven Club, the Memphis Players Union Local No. 71, and the personal collections of David Winkler, Donald Bruch, and Dan Handwerker. Gratitude is extended to Memphis Public Library graphic artist Gabriel Vaughn, who diligently scanned many of the items used in this book.

History informs and entertains. We learn from it, we repeat it, we learn not to repeat it, and we are amused or inspired by its lessons. This process is particularly delightful when explored with students. To that end, Rhodes College students Daniel Anglin, Eden Badgett, JoBeth Campbell, Ruth Houston, and the students in my courses shared the joy of primary research as they assisted in the discovery of some of the material in this book.

Our understanding of the significant contributions made by German Americans to the history of Memphis has been enhanced by the generous contribution of Dr. Anna Maria Cannaday Burns. Dr. Burns sponsored the 2006 German Heritage Seminar at the Memphis Public Library and Information Center resulting in the acquisition of several important items that add to the Memphis and Shelby Room collection.

Gratitude is expressed to Dr. Jim Johnson, Patricia LaPointe, Wayne Dowdy, Gina Cordell, and the staff of the Memphis and Shelby County Room of the Memphis Public Library; Rhodes College archivist Elizabeth Gates and the staff of the Paul Barret, Jr. Library at Rhodes College; Laurie Pyatt and John Sprott, Memphis Players Union Local No. 71; Donald Bruch; Dan Handwerker; David Winkler; Pam Dennis; Charles Crawford; and Jane and Emma for their never-ending patience, support, and love.

INTRODUCTION

Memphis is music. The city's name is synonymous with new genres and styles of music and has been for the greater part of its existence. The relationship was solidified in 1909 when W. C. Handy wrote the song "Mr. Crump," later publishing it as the "Memphis Blues." "Beale Street Blues" and "St. Louis Blues" followed. As these songs and the sheet music that freighted them across America were sung in the halls and the streets, a spotlight began to shine on a new incubator for music innovation—Memphis, Tennessee.

Today hundreds of thousands of visitors pour into Western Tennessee, Northern Mississippi, and Eastern Arkansas to momentarily visit the icons that resulted from what happened musically in Memphis. Destinations include Helena, Arkansas; Clarksdale, Mississippi; and the epicenter of the region's music, Memphis. Places such as Beale Street, Stax and Sun Records, and Graceland say it all. These monuments to the ephemeral world of music are evidence of the story that grew layer upon layer throughout the 20th century and produced a part of the sound track for every American.

But what is the story of the music of Memphis "before the blues?" Why Memphis? Why did Elvis Presley get his start in Memphis? Why did rockabilly, soul, and rock begin in Memphis? Why was Memphis home to Hi Records, Stax Records, and Sun Records? Why do rock stars from around the world travel to Memphis to trace their blues roots? Why did Handy, Father of the Blues, begin his publishing career in Memphis? These "firsts" are recognized around the world as the starting place for the history of every genre of popular music today and as part of the 20th-century Memphis history.

Peel back the decades of the 19th century and a fascinating precedent takes shape. A new set of "whys" emerges that predates blues, country, rockabilly, and rock and roll. The list is extended in *Memphis Music: Before the Blues* before Mr. Handy and the naming of the blues. Why did two of the founding members of the Fisk Jubilee Singers, popularizers of the African American spiritual, come from Memphis? Why did the first musicians' union form in Memphis? Why did the first federated music club for children in the United States organize in Memphis? Why was Memphis home to the largest piano distributor in the South? Why did the song "Dixie" get its boost of popularity from Memphis? Why did the first orchestral performance by John Philip Sousa take place in Memphis? Again, why Memphis?

Memphis Music: Before the Blues surveys the people, music, and events that contributed to the story of the rich musical life that emerged in Memphis against the backdrop of Civil War and disease in the second half of the 19th century. The story presents the seeds that led to ongoing innovation and creativity that comes from a convergence of people of different cultures. That is the story of Memphis in the 19th century, and music was the seed that took root and grew, generation after generation. This story is about the creative soil and soul of the Delta, where music emerged in new and innovative ways in each succeeding decade.

Christopher Philip Winkler arrived in Memphis in 1854, just as the town was emerging from its status as a wild, western river port into a strategic cosmopolitan city of the South. Thirty-five

years later, at the summit of his musical career, Winkler offered the following reflections in the daily paper: "When I came to the city, in 1855, the prevailing style of music was 'Oh! Susanna, Don't You Cry,' 'Old Dog Tray,' and 'My Old Kentucky Home.' Nothing else would go at concerts. The great moving power in those days were the choirs, although the music, except in the Catholic Church, was poor enough. There was little improvement perceptible until after the war."

Winkler arrived in a city that loved to hear plantation songs such as those written by Stephen Foster. Minstrel songs were popularized by traveling troupes such as Christy's Minstrels and itinerant minstrel and vaudeville shows. However, by the time of his writing in 1890, Winkler was conducting performances on multiple evenings of Carl Maria von Weber's grand opera *Der Freischütz* to capacity audiences. By the 1890s, repertoires heard in the theaters, music halls, and chamber salons throughout the city included the names Handel, Mozart, Haydn, Mendelssohn, and Wagner. In private homes, pianos bearing the names Chickering, Knabe, and Steinway fostered music making by cultured amateurs taught by well-schooled European immigrants. Students learned classical European literature as well as a growing body of new American classics. These works were delivered to them by sheet music published in Memphis by German publishers and sold by music dealers named Witzmann, Katzenbach, and Hollenberg. Winkler's own compositions brought a new dimension to the prevailing music of Memphis, incorporating European characteristics while accommodating local popular taste. At the end of his career, Winkler would earn the title "Dean of Memphis Musicians."

Winkler was one of thousands of immigrants that populated Memphis in the second half of the 19th century. Immigrants from Italy, Germany, Ireland, Switzerland, and France came to Memphis as they sought a better life in this new frontier area. The German population of Memphis, while not the largest immigrant group in number, was by far the strongest group in terms of musical influence and musical contribution to the educational, cultural, social, and economic life of Memphis. In music and theater, they reined supreme over every other immigrant group, including any native influence in the city. From the newspaper accounts of the second half of the 19th century, Germans instigated the musical backdrop for everything that happened civically in Memphis. Concerts, tours, productions, operas, musicals, festivals, parades, and recitals were all attached to sponsoring names such as Mozart Society, Beethoven Club, Mannerchor, Bruderbund, German Casino, and German Theatrical Company.

The Western District of the United States, which became Western Tennessee, was originally the home of the Chickasaw Indians. In the early 18th century, the French established a garrison on a bluff overlooking the Mississippi River, and when Spain later took possession of the Louisiana territory, they occupied this same strategic location with a military presence. When the area came into the possession of the United States, a town was laid out on the bluff that bordered the Mississippi River. Memphis was the name given to this town on the river Andrew Jackson called the "American Nile."

The Mississippi River transports soil to the Mississippi Delta below Memphis, and as a result of the crops of this fertile region, the same river transports these crops, people, and other products to all points above and below this central location. An affluent and cosmopolitan population developed in the city that in the best years enjoyed the luxury of discretionary leisure time for the arts. In a pamphlet published in Philadelphia in 1820, the following description of Memphis, attributed to Andrew Jackson, is given:

> The plan and local situation of Memphis is such as to authorize the expectation that it is destined to become a populous city. It is laid off parallel with the Mississippi, the course of which at this place is nearly due south, with Wolf River emptying into it at the northern extremity of the town. . . . The frequent passage of steamboats and crafts of every description, up and down the Mississippi, give grandeur even to the prospect, and an active and commercial appearance to the place, which is only one remove from a position on the seaboard.

The strategic location described by Jackson became the reason for the prosperity of Memphis, as well as the central ingredient that led to the growth of a convergent population by people from many faraway places. These people came from Ireland, Africa, Germany, France, and Italy. While each group made their distinctive contribution to the life and culture of Memphis, it was German and African American musicians that forged the musical foundations of the city.

In 1796, the area that was to become Memphis was still a county in North Carolina. African slaves were sold or brought to plantations in the rich agricultural areas that constitute the Mississippi Delta. These plantations were operated by a small group of residents that formed the upper class. The slaves brought their love for music as well as skills and creative, inventive ingenuity. They had little more than a mixture of hope and despair. As they adapted their musical gifts to their life and faith, new musical styles developed, which included spirituals, gospel, blues, and rag.

As Irish, German, and Italian immigrants populated the area, they too brought skills as well as hope for a better life. While most Africans remained in forced slavery, the Irish often constituted the lowest level of the working class. However, as free and trained artisans and craftsmen, Germans and Italians quickly established a solid middle and upper middle class. They adapted to the musical styles they found in their new home, and the talented and trained musicians among them brought the cultivated musical culture they had learned and known in Europe.

Cotton, more than any other commodity, is the reason for the massive migration west, both on the part of African Americans through forced slavery and European immigrants seeking new opportunity. The land rush that resulted from the invention of the cotton gin and the ability to produce greater amounts of the raw material brought slave and free, poor and rich, to the Mississippi Delta. Memphis as a cosmopolitan center is a result of the western pursuit for land to grow cotton and the transportation means to move people and goods to and from this strategic location. This pursuit set the stage for the ingredients necessary for a thriving musical and artistic culture in Memphis: population, affluence, and leisure time. In the years that followed the westward expansion to Memphis, these ingredients combined to produce an export even greater than cotton—the ephemeral product of music.

German settlements in Pennsylvania and North Carolina predate the founding of the United States, and performances of German music were among the first classical performances in the New World. Compositions by Germans such as Bach and Handel were performed in these German communities before Philadelphia was the first capital of the new country. George Washington was entertained by early German settlers who played this music in Bethlehem, Pennsylvania. Benjamin Franklin played string quartets composed by German immigrants that had recently settled in the New World. German instrument makers such as Moravian organ builder David Tannenberg were among the first to build instruments in the New World.

When the nation of the United States of America was born, 250,000 of the new citizens were of German origin. By the early 1800s, Germans, Italians, Irish, and other immigrants began moving west to new settlements such as Memphis. Most of the newcomers were already in the South, drifting west from Virginia and North Carolina. Nearly a quarter of the newcomers were recent foreign immigrants, primarily from Ireland and Germany. Among the Germans migrating west, there were a few Jews.

In the years that followed this westward expansion, two cataclysmic events in the form of war and disease threatened and delayed the city's artistic growth but ultimately did not destroy the coming together of the foundational ingredients for music to flourish.

In the 1850s, the popular music was the plantation songs sung by the traveling minstrel shows such as Foster's "Nelly Was a Lady" that entertained the town settlers along the Mississippi River. The lyrics to these songs give historical insight and historical record for the cotton culture and slave labor of the times:

Down on the Mississippi floating,
Long time I travel on the way,

All night the cotton wood a toting,
Sing for my true love all the day.

Nelly was a lady
Last night she died,
Toll the bell for lovely Nell
My dark Virginny bride.

Cotton was the king industry in the region, and slaves from Virginia and North Carolina populated the cotton fields of the Mississippi Delta from Memphis to Vicksburg. Into this environment came the large wave of immigrants from Europe, including the primary musical movers and shakers, the Italians and the Germans.

The first record of a German settler in Shelby County, Tennessee, was in 1832. A German merchant named Rasch settled in the area east of Memphis. He was followed by other German merchants and farmers, and the area was later named Germantown. As Memphis grew just to the west of Germantown, future immigrants moved to Memphis, leaving Germantown with the name but not the Germans.

Irish, Italian, and German immigration into Memphis continued in the 1840s and reached high levels by the end of the decade. Memphis was one city among many in the United States that collectively absorbed thousands of German and Italian musicians. New York, Boston, Philadelphia, St. Louis, and Cincinnati caught the first wave of this European skill and talent, but the emerging port cities of Chicago and Memphis followed closely. German migration into Memphis eventually transformed the musical and artistic life of the city.

Of the 22,623 citizens of Memphis in the late 1850s, 11,803 were white and native to the area; 4,159 were Irish; 3,882 were African American; 1,412 were German; 522 were English; 120 were French; 113 were Scots; and 472 were from other places of origin. The influence the Germans exerted on the musical culture of the city far outdistanced their numbers and that of any other group.

As more and more immigrants moved to Memphis, the city emerged with an urban sophistication. William Miller noted, "One could hear the songs of Haydn and Schubert sung by a Mannerchor, while trade unions and new currents of thought were discussed and frequently espoused in the several newspapers published by the Germans." The 1840 census listed a population of 1,799 people in Memphis. By 1850, that number had quadrupled to 8,841. Of those early residents, 44 were registered as Germans. By 1850, that number was almost 10 times the earlier listing. It was clear that by mid-century Memphis had become a serious destination for European immigrants.

German Immigration to the United States, 1821–1900

1821–1830	6,761
1831–1840	152,454
1841–1850	434,626
1851–1860	951,667
1861–1870	787,468
1871–1880	718,182
1881–1890	1,542,970
1891–1900	505,152
Total	5,099,280

In Memphis, it was Germans and Italians more than any other group that made the strongest permanent impact on music in the 19th century. German and Italian leadership was evident in the musical commerce of the city. In piano and organ trade, firms bearing the names of Flavio, Katzenbach, Witzmann, and Hollenberg were prominent. Germans inspired the music clubs and

societies that led to the establishment of the Memphis Symphony Orchestra and other permanent music organizations. German and Italian educators established the music institutes that led to the music departments of the local colleges and universities. German entrepreneurs brought the traveling performers, opera companies, and bands that frequented the river port city. Germans formed the first musicians' union in the United States in Memphis.

The potato famine of 1847 in Ireland resulted in the high wave of Irish immigrants coming to Memphis. In Germany, political instability in 1848 along with the combination of overpopulation and crop failures led Germans to leave their homeland by the thousands. Memphis and other American cities were attractive to European immigrants for as many positive reasons as there were reasons to leave Europe. These included the availability of land and new opportunity, favorable citizenship status, and religious freedom, and by the 1850s, many family members and friends had already settled in the United States from Europe. Ship transportation made the trip affordable and possible in a relatively short amount of time.

In Memphis and other American cities, to be a trained German musician was equivalent to possessing a terminal degree in music. Many capable German and Italian musicians arrived in the United States throughout the late 1840s. The Germans who came to Memphis remained German in name and custom throughout the 19th century. They formed cultural societies for the stated purpose of perpetuating German music, language, and other customs. Nearby towns in West Tennessee reflect the German and Swiss influence of their founders with town names such as Wartburg, Gruetli, Hohenwald, Newbern, Dresden, and Germantown.

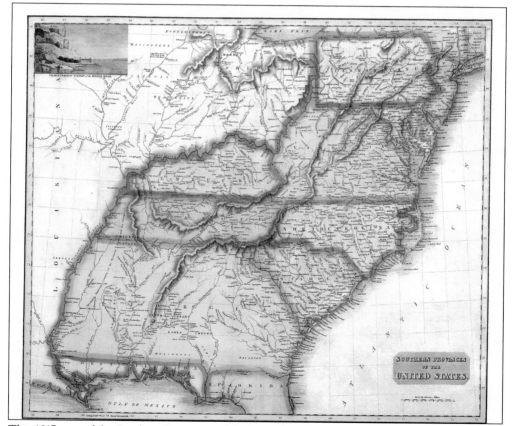

This 1817 map of the Southern Provinces of the United States shows Tennessee (spelled "Tenassee" on the map) as a western extension of the state of North Carolina. The city of Memphis is not yet listed on the map.

According to Gerald Capers, real estate and slave values reflected the general prosperity of Memphis during the 1850s. Property valued at $200 in 1850 sold for $2,000 in 1855. Slaves who worked in the fields were sold for $750 to $1,000, but slaves who worked as carpenters were sold for $2,500, and blacksmith's hammerers were sold for $1,114.

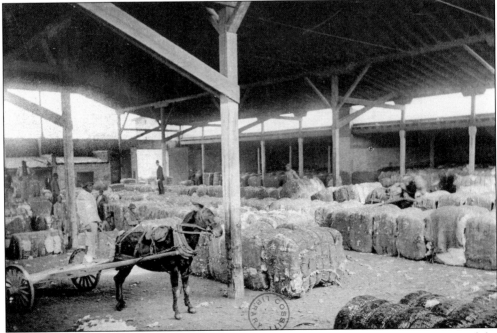

Memphis was the child of cotton. By the 1850s, westward migration and the expansion of the South made Memphis a commercial rival to New Orleans, having already bypassed both Vicksburg and Natchez in cotton trade.

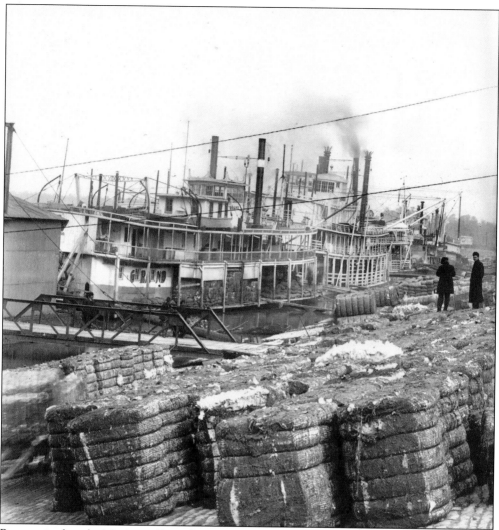

Boats arrived on the Mississippi River from tributaries all along the route above and below Memphis. Small flatboats were used to bring cotton and commodities to market. Prior to Mayor William Spickernagle in the early 1840s, boatmen refused to pay fees to dock in Memphis. However, he formed a militia, and fees were extracted from the boatmen. Historians mark this turn of events as the point Memphis transitioned from small town to emerging city.

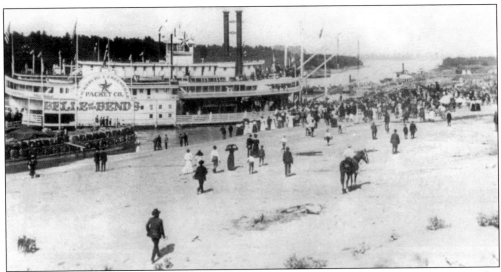

Memphis is strategically located on the Mississippi River between the upper Mississippi valley and the lower valley, making it a vital distribution hub in every direction.

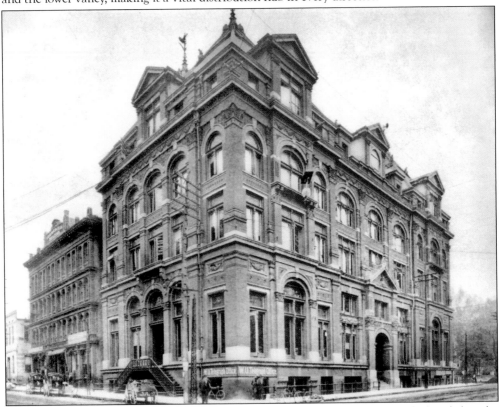

In the *Memphis City Directory* for the years 1855–1856, Rainey optimistically declared that the mid-1950s were the "four and five story era." By this, he meant that the height of the buildings of the city had now reached a four- and five-story level, signaling the unprecedented prosperity of the times. He continued, "Our gaze is over the immensity of the Southwest, which our railroad arms will soon comprehend. What Era of Stories Next?"

One

MEMPHIS
A Musical Province of Germany

In 1848, a group of 24 Germans came to the United States, forming what was called the Germania Orchestra. This ensemble toured the country, demonstrating a level of performance detail that set a new standard of excellence for music making in the United States. This year signaled the first great wave of immigration by European musicians.

Memphis and other American cities were attractive to European immigrants for as many positive reasons as there were reasons for them to leave Europe. This motivation included professional opportunity, the availability of land, favorable citizenship status, religious freedom, and, by the 1850s, family members and friends that had already come to the United States from Europe. Ship transportation now made the trip affordable and possible in a relatively short amount of time.

In nearby Jackson, Tennessee, as in Memphis, the professors that came and taught at the Female Institute and the Baptist University were a part of this German musical literati. Christopher Philip Winkler, Charles Utermoehlen, Erwin Schneider, Rudolph Richter, and Carl Beutel were among the German immigrants who taught music at these institutions.

The Germans who came to Memphis remained German in name and custom throughout the 19th century. They formed cultural societies for the stated purpose of perpetuating German music, German language, and other German customs.

Italians and Germans made their mark immediately upon a new cultured music that began to grow in Memphis in the late 1840s and early 1850s. Italian immigrant Philip Flavio established the first retail music store in Memphis in 1846, advertising "the latest and most popular in sheet music from the Eastern market—polkas, quadrilles, duets, marches, quicksteps, and waltzes." His store offered pianos and other orchestral instruments. Flavio became the first music publisher on record in the city.

The first attempt to create an orchestra in Memphis was made by Italian immigrant "Signor" Carlo Patti. Patti, a handsome violinist, had been an orchestra leader at a theater in New Orleans before coming to Memphis. He led in the development of the first musical societies in Memphis by recruiting local talent for a Mozart club and the Philharmonic Society. An advertisement in the March 6, 1861, *Daily Appeal* for the New Memphis Theater listed Signor Carlo Patti as the theater's musical director. Also playing that same week in Memphis for three nights at the Odd Fellows' Hall was Memphis favorite "Tom, the inspired little blind negro boy pianist," affectionately referred to in future engagements as "Blind Tom."

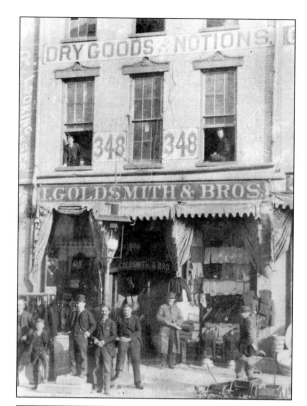

German skill and prowess were not limited to music. Germans brought leadership to other aspects of life in Memphis. William Spickernagle, a German cabinetmaker, became mayor of Memphis in 1841, leading a reform ticket that established two militia units that forced flatboatmen to pay fees for using Memphis docks when other cities were unable to collect for this service. Flatboats arrived in Memphis on the Mississippi River from tributaries all along the route from Missouri, Kentucky, Indiana, and Illinois. These small flatboats were used to bring commodities to market in Memphis. Historians mark 1841 as the turning point for Memphis as it moved from a small river town into its status as a western business center. German immigrants soon established solid businesses in other trades: Frederick William Brode opened a cotton seed product business in 1868; Herman Gronauer traded in wine; Louis Hanauer established a general merchandise trade; and the names Lowenstein (pictured bottom), Gerber, and Goldsmith (pictured top) were associated with clothing stores.

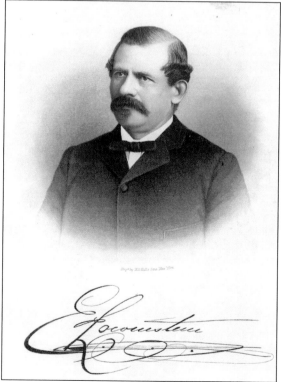

Across the country, German piano makers were coming to the new land of opportunity. Most of their names have been forgotten, but not Wilhelm Knabe and Henry E. Steinway. Steinway (originally Steinweg) established a piano empire in the United States that became the standard of excellence for American pianos. Steinway arrived in New York in 1850 from Braunschweig, Germany. Three years later, the firm Steinway and Sons was founded. Germans and Italians shaped the very language and way Americans think of music. German precision is reflected in the language used for musical notation. Musicians in the United States use the terms quarter note, eighth note, sixteenth note, and so on to describe the length a note is held. Few realize that this is German precision and German thinking at work. In England, the terms minim, crochet, quaver, and semi-quaver were the language of note values, then and now. Germans made Americans stop speaking English—musically, that is—and start speaking the logical German nomenclature of mathematical note values.

The same distinction can be applied to the language transplanted to the United States by Italian musicians. Italian interpretation and musical character remained in American conversation, teaching, and publication. If music was loud, it was played *forte*. To slow music down, composers and arrangers wrote the indication *allargando*. These Italian terms and hundreds more appeared in the titles and markings of American publications. Germans and their English-speaking adherents in Memphis taught and played Beethoven, Schubert, Schumann, Bach, Mozart, Mendelssohn, and later Wagner. In Memphis as well as other leading American cities, when it came to music, the United States had become a musical province of Germany.

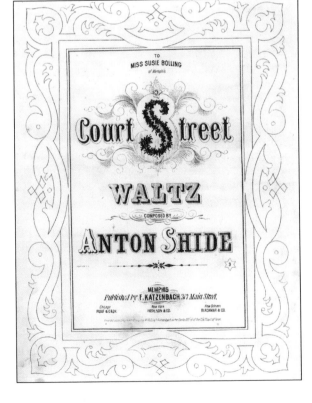

Two

POPULATION, AFFLUENCE, AND LEISURE TIME
A Formula for the Arts

Prior to the arrival of the converging immigrant population, Memphis could still be characterized as a wild western town. The ingredients of population, affluence, and discretionary leisure time had not yet combined to stage the artistic climate that was to come. The population of Memphis in 1850 was 8,841. The most solid musical organizations were the choirs that existed in the churches. The newspaper of the day offered the following picture:

> Who is not delighted at the sound of the soul stirring music? Who does not feel that ours is not a happier world when his senses are overwhelmed with the waves of mellow sounds? If your soul pulsates at the thrill of melody, do not allow this opportunity to pass: Go and hear the Philharmonic Vocalists. They will give a concert at the Episcopal Church Wednesday night for the benefit of that church. Mr. Flavio will preside at the organ.

The impact these churches made upon the cultural and literary life of the community remained strong throughout the 19th century and even remains strong today. Both Trinity Lutheran Church and St. Mary's Catholic Church relive and note with pride their German heritage through activities such as the current Germania Club, the continuation of a version of the Mai Feste in Memphis, and Trinity's annual German Christmas Service.

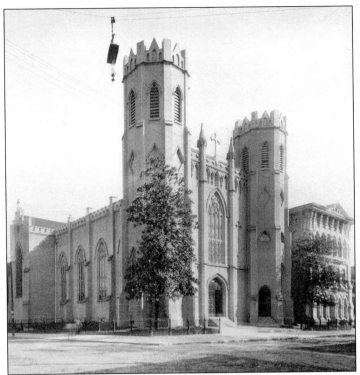

Swedish residents established a Swedish Lutheran church, and the Polish Jews of the city established an orthodox synagogue. Germans founded five churches, including the German Evangelical Lutheran Trinity Church of the Unaltered Augsburg Confession (later Trinity Lutheran Church); a German Protestant Evangelical church; a German Presbyterian church; and Temple Israel, Children of Israel Jewish congregation. In 1852, German Catholics organized the Society of St. Boniface, which became St. Mary's German Catholic Church.

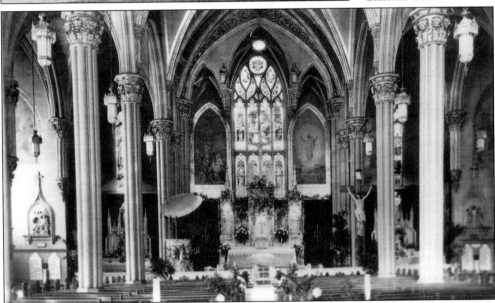

The Irish of Memphis established St. Peter's Catholic Church (pictured), and Italians also established a Roman Catholic church. The impact these churches made upon the cultural and literary life of the community remained strong throughout the 19th century and into the present day. The "Dean of Memphis Musicians" was German-born Christopher Philip Winkler (1824–1913), who immigrated to the United States at the age of 16. Born in Gutenstetten, Germany, near Munich, Winkler received his musical training before leaving Germany at the Royal Conservatory of Munich (later the Richard Strauss Conservatory).

In his last will and testament of 1905, Winkler reflected on his steamship passage to America:

> Leaving home on foot and walking all the way to Bremen . . . I took passage in a lighter for Bremerhaven and there was transferred with a big number of others, men mostly and a few women, to a brig which brought us after a voyage of fifty six days to Philadelphia.

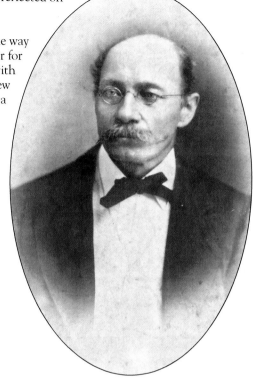

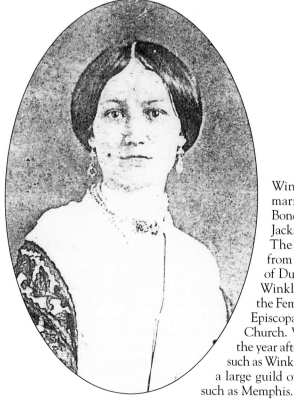

Winkler came to Memphis in 1854, newly married to former student Susan Margaret Bond, after teaching at the Female College in Jackson, Tennessee (later Lambuth College). The couple purchased a piece of property from Bond's father on the southeast corner of Dunlap and Poplar Avenues in Memphis. Winkler immediately began teaching music at the Female College in Memphis (later St. Mary's Episcopal School), housed in Calvary Episcopal Church. Winkler remained in this position until the year after the Civil War. German music teachers such as Winkler carried the title "professor" and formed a large guild of German teachers in American cities such as Memphis.

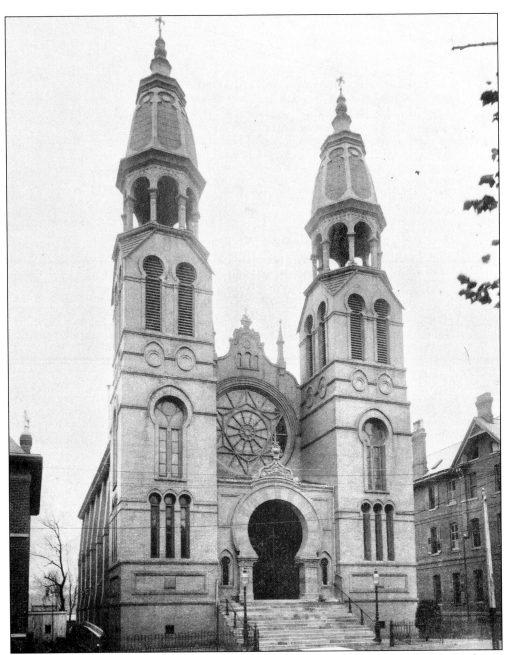

Winkler and the Italians Philip Flavio and Carlo Patti were at the forefront of the best of civic music making in the theaters, churches, and schools at the halfway point of the century. Winkler became organist in 1857 at Temple Israel, Children of Israel, located at Main and Exchange Streets and later Poplar Avenue (pictured). In addition to his other professional responsibilities, Winkler pursued the study of Jewish music carefully and, in his words, learned the "peculiar character of the music of Jewish composers." Winkler composed most of the music for the services he played during his tenure at Temple Israel, which amounted to over 850 compositions by 1894. Winkler's success was apparent, and many years later, Elias Lowenstein declared, "The choir under the direction of Professor Winkler continues to charm all who attend our services."

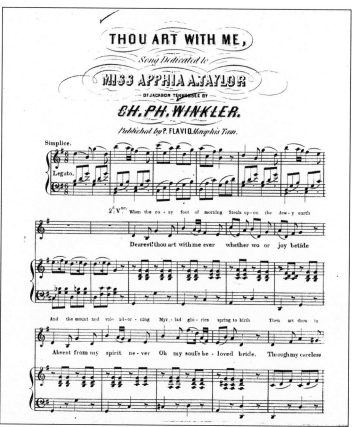

Flavio was organist at Calvary Episcopal Church and gave concerts at that location. He was a composer and arranger, concert manager, teacher of piano, and music publisher. His publications reflect native Italian characteristics, the typical dedication to a female student, and the stylistic trends of such publications. Flavio received the label of the most versatile and entertaining musician of his day. He published his own compositions as well as those by Winkler, including Winker's piano solos "Old Maids' Polka" (1852) and "Reflections of Memphis" (1854). Published sheet music from this time carries the imprint of "P. Flavio Publishing," and by all indications, Flavio remained a prominent musician in Memphis throughout the 1850s. Flavio died in Memphis on June 10, 1859, at the age of 46. Retail music establishments continued to be added in the 1850s. After Flavio began his music store in 1846, he was joined by additional commercial firms that sold and repaired instruments, supported music instruction through the sale of instructional manuals and sheet music, and offered music lessons including instruction in piano and violin. Henry G. Hollenberg, Frederick Katzenbach, Prof. ? Mueller, Henry Seyfert, Emile Witzmann, Christopher Philip Winkler, and John George Handwerker, all Germans, were listed as music professors at these establishments. According to the press of the day, in addition to Flavio's establishment were Barbiere's, McKinney and Company, Grosvenor's, Benson's, and the firm of H. G. Hollenberg. H. G. Hollenberg was born in Hanover, Germany, in 1821. His education in Germany included a seven-year apprenticeship in piano manufacturing, traveling all over Europe refining his skills as a musician, as well as building a knowledge of the details of piano manufacturing. Hollenberg came to New York in 1848 and under the firm name of Hollenberg and Company began manufacturing pianos that carried his name. The company was located at 15 Franklin Street, New York. He relocated to Memphis in 1853 and opened a music establishment. In 1858, he opened a piano store in Huntsville, Alabama, but this effort was interrupted by the Civil War. In 1866, Hollenberg returned to Memphis broken in fortune but not in spirit and started over again, this time succeeding in the piano business.

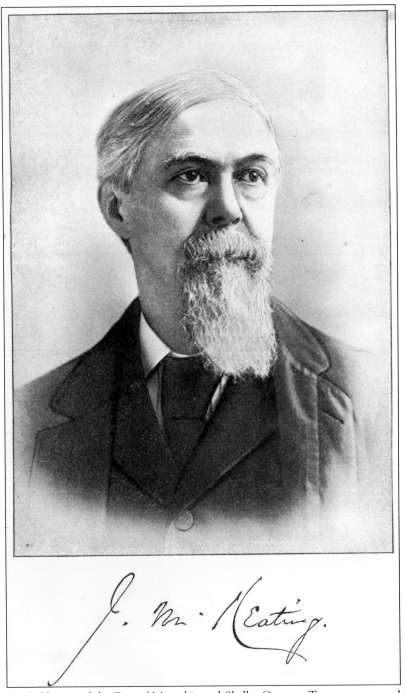

J. M. Keating's *History of the City of Memphis and Shelby County, Tennessee* was published in 1888 and provides a contemporary account of the significant events that shaped the city's history. As publisher of the Memphis *Daily Appeal* newspaper, Keating's first-hand accounts as historian, journalist, and resident are invaluable. According to Keating, himself an Irish immigrant, there were five German-language newspapers published in the city in the second half of the 19th century.

After Memphis fell to the Federal army in 1862, *Die Neue Zeit* (*The New Era*) was established by Peter Walser (pictured). Walser's paper was radically Unionist in sentiment, remaining in publication for five years. Walser, born May 31, 1810, was also apparently a practicing musician. An advertisement shows a "Vocal and Instrumental Concert" (below) was offered to the public on June 18, 1886, at Theiler Hall, Bluff Street, under the direction of Walser. German, Swiss, and French cultural organizations were formed in the early 1850s, and their importance grew as the city grew. Perhaps in no other area did the Germans leave the lasting imprint on Memphis as they did through their musical organizations. Germans were responsible for over 30 social clubs, lodges, and organizations dedicated to music. Through their Mai Feste outdoor festival and participation in Mardi Gras, they introduced Memphis to the festival practices of Europe. The earliest of these organizations were the Philharmonic Society and the German Casino Club organized in 1857. The mission of the German Casino Club was "the cultivation of German habits, the perpetuation of their languages, and the means for general sociability." These clubs were restricted to Germans, but their cultural activities and performances were presented to the public.

Vocal and Instrumental Concert,

—UNDER THE DIRECTION OF—

PROF. P. J. WALSER,

TO BE GIVEN ON

Monday Evening, June 28, 1886,

AT THEILER HALL, BLUFF STREET,

ADMISSION, - 25 CENTS A PERSON.

GREAT CELEBRATION
OF THE
Centenary of the Birth of
ALEXANDER VON
Humboldt
By the citizens of Memphis,
On September 14th, 1869
AT
DUNN'S GROVE.

All Societies will meet at
MARKET SQUARE AT 8½ O'CLOCK,
And will march through Main Street to Beal, out to the Dunn
Place, in the following order:

Band---Turner Boys,
Irish Literary Association,
German Benevolent Society,
Grutly Society,
Druids,
Bruderbund.
Citizens generally.
CARRIAGE CONTAINING ORATORS OF THE DAY,
Turner Society, Citizens in Carriages.

Arrived on the place they will rest until 12 o'clock M., when the Celebration will
be inaugurated as follows:

Overture from Bach—STRING BAND.	Pot pourri: Faust—String Band.
Welcome Speech—P. WALSER.	ORATION by JUDGE H. S. LEE.
Pot pourri—Il Trovatore.	Pot pourri: Cornet Solo—String Band.
Dies ist der Tag des Herrn— By the Concordia.	Wer hat dich du schoner Wald— Concordia.
Coronation March— Brass and Reed Band.	Aria: Cornet Solo— Brass and Reed Band.
Oration by JAS. A. GRONAUER.	Gymnastic Exercises & Popular Games.
Trumpet Gallop— Brass and Reed Band.	Beautiful Isle of the Sea— Quickstep Band.
Stimmt an mit hellem hohen sang— Concordia.	Auf die Hohen muszt ihr steigen— Concordia.

After which Dancing will commence
And be kept up to a late hour.

THE BAND PLAYING FOR THIS OCCASION IS THE
CELEBRATED CITY BAND.

Refreshments will be furnished on the Grounds
AT REASONABLE RATES.
No Disreputable Characters Admitted.

The first German newspaper published in Memphis was *Die Stimme des Volks* (*The Voice of the People*). It was a weekly, edited by August Kattmann and first published in April 1854. Kattmann left Germany after the revolutionary period of 1848. In his paper, he opposed the existence of slavery in the South. *Der Anzeiger des Sudens* (*The Southern Advertiser*) was published by Louis Wundermann and first appeared on April 15, 1858. It was politically independent and enjoyed a large circulation. This newspaper remained in circulation until January 1, 1876. The *Memphis Democrat*, a German daily newspaper, was published during the presidential campaign of 1860, supporting Stephen A. Douglas for president. When Douglas lost the election, the paper ceased operation. Walser's *Die Neue Zeit* (pictured above) ceased publication in the 1870s and was replaced by a German-Democratic paper, the *Memphis Correspondent*, published by Pappendick, Trauerndot, and Company, but remained in business only a few months. These newspapers chronicled the activities of societies such as the Memphis Gruetli Verein, which formed in 1855 with a group of 70 members. This association was limited to those of Swiss heritage and adopted German as its language. Their name was often associated with artistic efforts and the higher cultural affairs of the city. This group sponsored annual balls and participated in festivals (pictured at left) as well as other German celebrations.

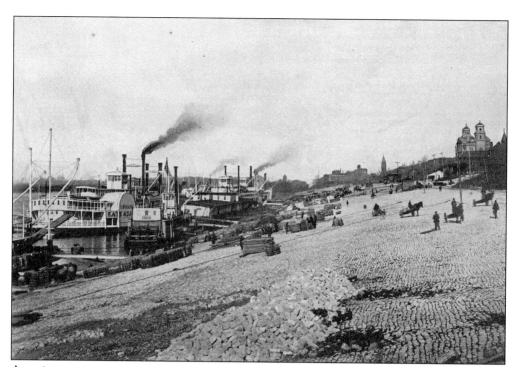

As a river port town with a large and growing population, Memphis regularly played host to touring musicians that worked the river circuit from St. Louis to Cincinnati to New Orleans. Steamboat travel was at its height of popularity and regularly brought circuit performers to Memphis. Luxury steamships carried orchestras up and down the river. River boats were called floating palaces, offering musical variety shows to crowds that would gather at the port cities. These entertainments included minstrel shows, circuses, solo performers including opera singers and instrumentalists, and vaudeville shows.

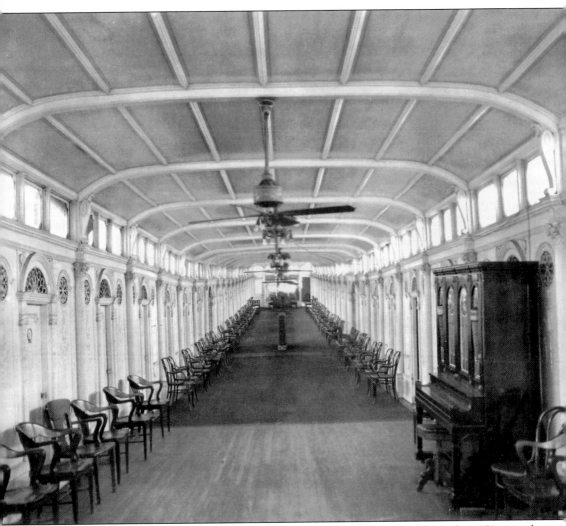

One of the leading indicators that Memphis was coming of age musically in the 1850s was the appearance of the guest musical artists of the day in concert at its performing halls or in concerts on the floating palaces (above). In the 1840s, churches had been the locations for the occasional concerts in this frontier town. However, by mid-century, performance spaces appeared throughout the blossoming city. By the fall of 1849, Thomas Lennox had converted a brick building on the northeast corner of Washington and Centre Streets into a well-arranged theater. Keating reports that after a season or two, Charles and Ash had become managers of it, "and during their control many of the most prominent stars in the theatrical firmament of that day, graced the boards of this theatre, among them being Eliza Logan and Edwin Booth." In 1857, another small hall, the New Memphis Theatre, was opened by W. H. Crisp on Jefferson Street as Crisp's Gaiety.

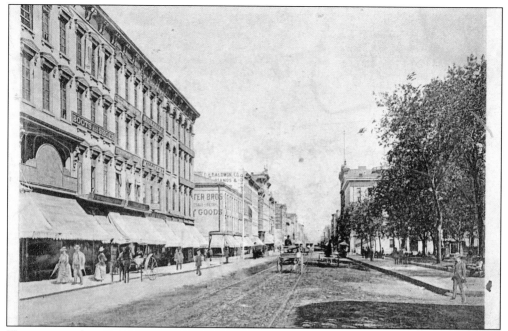

Flavio managed concert appearances by performers such as Anna Bishop. Venues included Hightower Hall, where Elisa Biscaccianti, a Boston coloratura soprano, performed in March 1850. Opening in 1851, Odd Fellows' Hall, with a seating capacity of 1,000, became the primary house for significant performances in the city. New York's Theodore Thomas made his solo violin debut at Odd Fellows' Hall in 1851. In 1853, the Swedish violinist Ole Bull included Memphis on his farewell tour of America. Louis Gottschalk, the outstanding American pianist, composer, and first American concert artist to achieve international fame, performed in Odd Fellows' Hall on May 29, 1853.

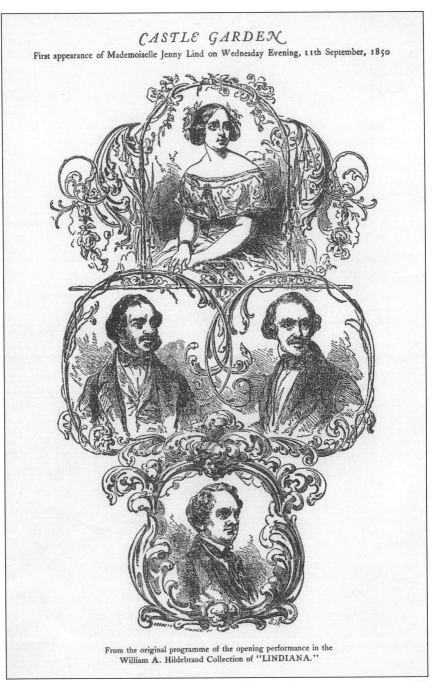

CASTLE GARDEN

First appearance of Mademoiselle Jenny Lind on Wednesday Evening, 11th September, 1850

From the original programme of the opening performance in the
William A. Hildebrand Collection of "LINDIANA."

By all measurements, the event of the decade in Memphis was the concert appearance of Swedish singing sensation Jenny Lind in her American tour. P. T. Barnum of circus fame was the manager and promoter of Jenny Lind's American tour of the early 1850s. Nicknamed the "Swedish Nightingale," Lind played to sold-out crowds throughout America. Her voice and personality combined to win the hearts of the country, so much so that her name became an endorsement for every type of merchandise imaginable. Her picture was as admired as her voice, and sales of her portrait advanced her concert appearances. On March 14, 1851, she came to Memphis.

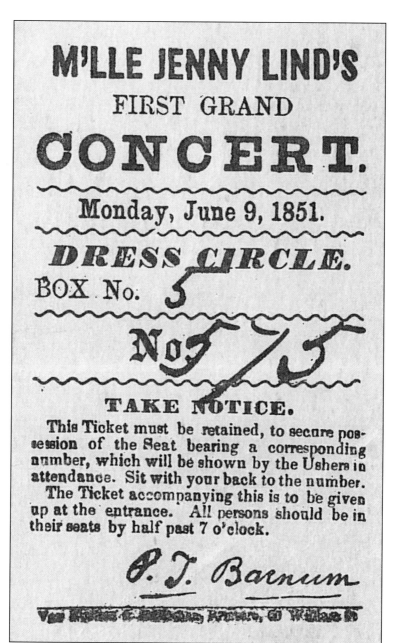

M'LLE JENNY LIND'S
FIRST GRAND
CONCERT.

Monday, June 9, 1851.

DRESS CIRCLE.
BOX No. 5

No. 575

TAKE NOTICE.

This Ticket must be retained, to secure possession of the Seat bearing a corresponding number, which will be shown by the Ushers in attendance. Sit with your back to the number.

The Ticket accompanying this is to be given up at the entrance. All persons should be in their seats by half past 7 o'clock.

P. J. Barnum

The audience filled Odd Fellows' Hall to capacity for the morning performance. Hundreds more stood outside the hall. Lind's repertoire was carefully crafted. Her concerts consisted of a combination of classical arias with tender ballads. The Memphis repertoire included a trio for voice and two flutes, "The Bird Song" by Karl Taubert, "The Herdsman Song," and the ballad "Home Sweet Home." For an encore, she performed Handel's aria "I Know that my Redeemer Liveth" from *Messiah*. In the winter of 1853, the Grand Italian Opera Company appeared in concert with the French Ballet Troupe at the Memphis Theatre. In 1855, Madame Rosa de Vries and the Italian Opera Company performed selections from *Norma*, *Il Trovatore*, and *Lucretia Borghia*. Opera troupes continued to play Memphis throughout the 1850s, including the New Orleans English Opera Company and the Italian Opera Troupe of New Orleans.

The first festival reported in the Memphis *Daily Appeal* took place on May 24, 1858. The event welcomed the arrival of summer and mimicked the fondly remembered festivals of old Europe

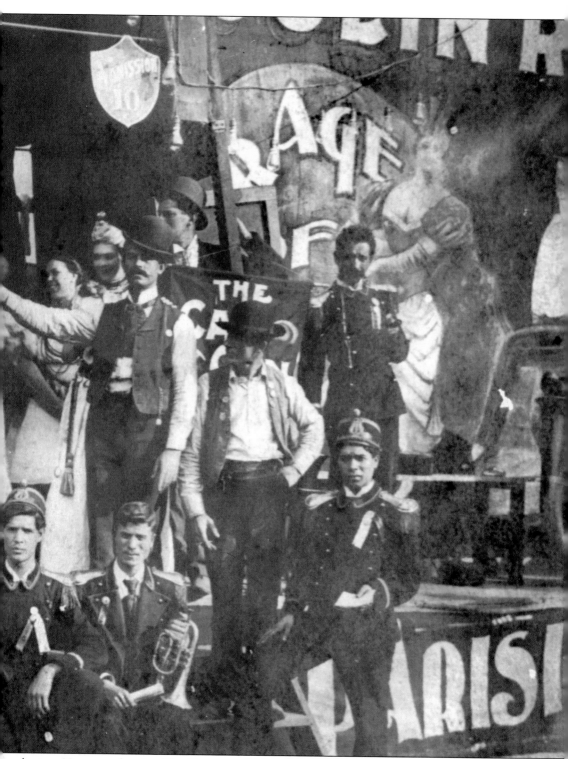

by immigrants to the city. The Germans of Memphis instigated this annual festival under the name of Mai Feste.

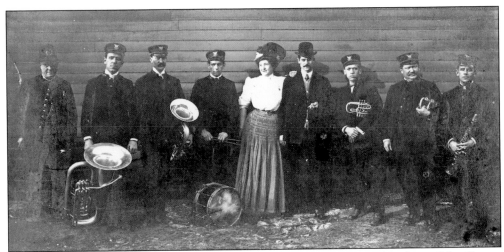

Mai Feste began with a large parade led by brass bands under the direction of Professors John George Handwerker, Herman Frank Arnold, ? Hessing, and ? Miller playing favorite Rhineland songs. The 1850s witnessed the organization of the first brass bands in Memphis, all led by Germans. The Memphis Brass Band was formed in 1850, and Professor Hessing formed the German band in 1853. On May 30, 1853, the *Daily Appeal* stated, "We return our thanks to our German friends for their delightful serenade last Saturday evening. The performers were worthy votaries of the noble music of the Rhineland."

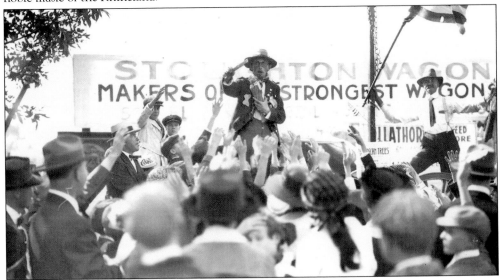

With the Mississippi River serving as a substitute for the Rhine, Memphis was transformed to a town in Germany on the day of Mai Feste. The various German societies gathered and showed their colors as the floats, May Queen, horses, wagons, and societies made merry to the sound of German brass bands. The choirs and choruses of the city sang their German songs, and a dance concluded the day's activities. The entire city of Memphis was invited to the festivities. At the eve of the new decade, the Germans of Memphis celebrated the centennial anniversary of the birth of Friedrich Schiller with a grand ball. This particular event was announced in the *Daily Appeal* on October 30, 1859, indicating that this anniversary was being observed by "every important city throughout the United States." The notice stated "various songs of Schiller, and other German songs, will be sung by accomplished vocalists."

Three

CIVIL WAR CHANGES THE TUNE

The United States census of 1860 demonstrates Memphis was growing at a new and rapid pace at the turn of the new decade. The city had almost tripled its population since 1850, growing from 8,841 in 1850 to a city of 22,643 by the end of the decade. Along with the growing population, wealth also grew, as did the level of trade and commerce. Ingredients were coming together that promised to advance the arts in the city.

In 1860, two important musical societies were organized: the Philharmonic Society and the Mozart Society. These all-male organizations were formed for the cultivation of music, the performance of orchestral compositions, and the establishment of a relief fund for needy artists. The first concert by the Philharmonic Society took place on December 1. The program consisted of orchestral overtures and vocal and instrumental solos.

Social and literary societies were an organizing force for a wide variety of concerns in Memphis, particularly in the area of the arts. The oldest society of this kind was the German Casino, organized in 1857. The purpose was to perpetuate all things German, including German language and customs, which at the forefront included music. According to Keating, the German Casino grew to be an indispensable institution, cultivating a taste for music and literature throughout the city.

Carlo Patti, leader of the Philharmonic Society and a popular violinist, conveyed his good wishes to his Memphis audience as he made his final concert appearance at Odd Fellows' Hall on Thursday evening, March 21:

> In bidding farewell to the public of Memphis, I have to acknowledge the universal kindness with which I have ever been treated, and I sincerely trust that upon this, my last appearance before my kind friends, their presence and patronage will justify me in the belief that I have lost nothing in their estimation during my brief but happy sojourn in the Bluff City.

Patti's program for the evening lists works by Carl Maria von Weber and Paganini and included guest appearances by his colleagues Frederick Katzenbach, Henry Seyfert, and the Gruetli Society

Chorus. This was Patti's farewell concert to Memphis as he left to enlist in the Confederate army. The same edition of the *Daily Appeal* gave notice that John George Handwerker was now the musical director at the New Memphis Theater, replacing Patti.

The Civil War brought life to a standstill in Memphis, including the advancement of musical life. New organizations were abandoned due to the war, and the activity of existing musical organizations came to a halt. In March 1861, enlistment posters were distributed and notices were posted in conspicuous locations throughout the city. The March 6, 1861, *Daily Appeal* ran the following notice:

> 10,000 Volunteers Wanted!
> Able-bodied Tennesseans can get employment at $8 a month, with jerked beef and crackers, in the ARMY of COERCION, to FORCE their Southern brethren into submission. None but Loyal Citizens to my Government and the UNION need apply. All good friends of the Union, will not wait to be drafted for Service in the government.
>
> For further information, apply to my beloved friends and AIDS, andy johnson and emerson elberidge [sic].
>
> <div align="right">Abraham Lincoln,
Com. in Chief, U.S. Army
Washington D.C. March 4th 1861.</div>

The following article appeared in the *Daily Appeal* on April 23, 1861, stating the German position toward Civil War:

> Germans! The Southern Republic has given us a home. It has secured us the same rights and privileges with the native born citizens. It has given a great many of us wealth, but to all it has given an opportunity to make and save money with but a little energy and diligence. Our interests are grown together with those of our southern home. Shall we now desert and abandon our southern brethren, who are striking for their good and sacred rights? No and never! That would not be German manner.

Keating reports that by January 1862, Memphis had changed radically. Throughout 1860 and 1861, preparations for Civil War in Memphis and throughout the South had continued, but by 1862, this activity receded. Cotton commerce had all but disappeared, and as cotton went, so went Memphis. Men of the city of voting age had gone to war, and the women were making clothes, assisting with military supplies, or working to take care of the wounded and dying in the hospitals. The streets of Memphis were dull. Using the formula needed for the perpetuation of the fine arts—population, affluence, and leisure time—all three had disappeared in Memphis as a result of the Civil War.

By September 1, 1860, the first school of music was established in Memphis by Clara Conway (1844–1904). Born in New Orleans, Clara Conway moved to Memphis in 1846. She was a prominent figure in the women's clubs and literary societies in Memphis and was one of the best-known educators in the South. The Conway Institute claimed a fine reference library, a well-equipped gymnasium, a science lab for the study of physics and chemistry, and a complete arts studio. Conway won the friendship of famous artists, musicians, authors, and scientists.

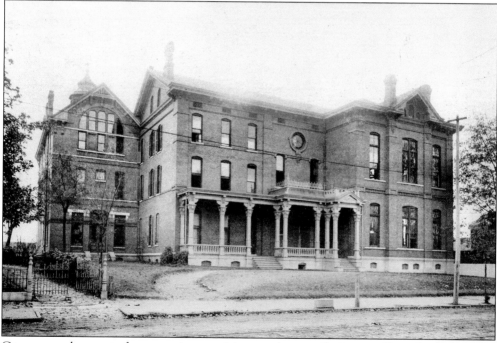

Conway was known to famous artists, musicians, authors, and scientists. Her school, the Clara Conway Institute, held a unique place in the region as a college preparatory program for young women. Conway's school offered courses in voice, piano, theory, and public speaking.

The Conway Institute was later joined by the Higbee School, established by Jenny Higbee.

Prof. Frederick Katzenbach, a German immigrant who had come to Memphis in the early 1860s, was an active music teacher during this era. He established a retail store for musical instruments as well as a publishing imprint located at 317 Main Street. An advertisement in the June 18, 1864, edition of *Die Neue Zeit* announced the sale of pianos and melodeons from Katzenbach's establishment. In the early 1860s, Christopher Winkler offered lessons in piano, organ, voice, and guitar out of Katzenbach's store. Katzenbach was a publisher of the compositions of Winkler, including his "Recollections of Childhood," published in 1866.

Between 1860 and 1865, a *Mannerchor*, or men's chorus, was formed under the leadership of Christopher Philip Winkler. This organization became one of the most important music and cultural organizations in the second half of the 19th century in Memphis. Winkler also played organ occasionally at Calvary Episcopal Church and, in the fall of 1865, served as organist at St. Lazarus Episcopal Church. After the Civil War, Jefferson Davis, former president of the Confederate States, was a vestryman at St. Lazarus, and the majority of the parishioners of the church were veterans of the Confederate army. The yellow fever epidemic in 1879 decimated the parish, leading to the merger of St. Lazarus with Grace Episcopal Church.

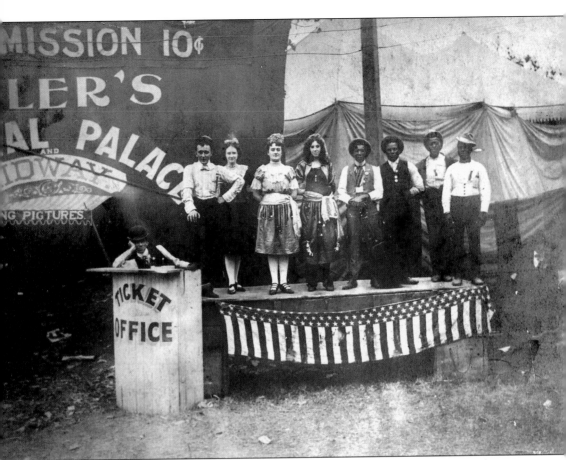

By March 1861, concerts, recitals, and minstrel shows had become regular and recurring entertainments in Memphis. Always in fashion and favor in Memphis, minstrel shows continued to please local audiences. George Christy's Minstrels and Brass Band appeared on March 11, 1861, at Odd Fellows' Hall for six nights of performances. The following notice was in the March 3, 1861, *Daily Appeal*:

> Comprising 16 splendid performers, under the immediate direction and personal supervision of the original and world renowned George Christy, whose performance for the last 18 years in the United States have been patronized by the elite and fashion of every city the George Christy Minstrels have had the honor of appearing in.

DixieLand

Emmet

ARRANGED BY

CHAS. HENLEIN.

PIANO SOLO 40c	PIANO 4 HDS. 50c	PIANO 6 HDS. 60c
	TWO PIANOS 8 HDS $1.20	

1st MANDOLIN SOLO	30	2nd MANDOLIN	15
1st GUITAR SOLO	30	3rd MANDOLIN	15
1st BANJO SOLO	30	2nd GUITAR	15
FLUTE	20	2nd BANJO	15
CORNET	20	PIANO ACCOMPANIMENT	30
VIOLONCELLO	20		

PUBLISHED BY E. WITZMANN & CO. MEMPHIS, TENN.

CHICAGO	NEW YORK	PHILADELPHIA
LYON & HEALY	J. FISCHER & BRO.	THEO. PRESSER

The Civil War brought a halt to most but not all musical activity. Prof. Herman Frank Arnold came to the United States from Prussia in 1854 at the age of 15. Arnold was a French horn player and as such met minstrel musician Dan Emmett in Montgomery, Alabama. Emmett had been asked to compose a piece of music for Jefferson Davis's inauguration as the president of the Confederacy. Emmett played the tune that came to be known as "Dixie" as the Confederate flag was raised over the capitol in Montgomery. Upon hearing "Dixie," Jefferson Davis told Arnold he wanted to make the song the South's official anthem. Since Emmett could not write music, the tune was played several times to Arnold, who copied it on the wall of a Montgomery theater.

ACTUAL-SIZE FACSIMILE OF THE ORIGINAL MANUSCRIPT OF

Dixie's Land.

Daniel D. Emmett.
"Dixie!" (1859)

"The original copy of 'Dixie', made on that rainy Sunday in 1859.
Daniel Decatur Emmett."
(Excerpt from letter identifying this manuscript.)

United Daughters of the Confederacy
328 N BOULEVARD
RICHMOND, VIRGINIA

"Dixie" has been variously attributed to Emmett as original composer, borrowed by Emmett from minstrel tradition, or as another version reports, adapted by Emmett from an old German hymn. Whatever the case, it was Memphian Herman Frank Arnold who arranged the song for band and published the first 50 copies of the music after Davis's inauguration.

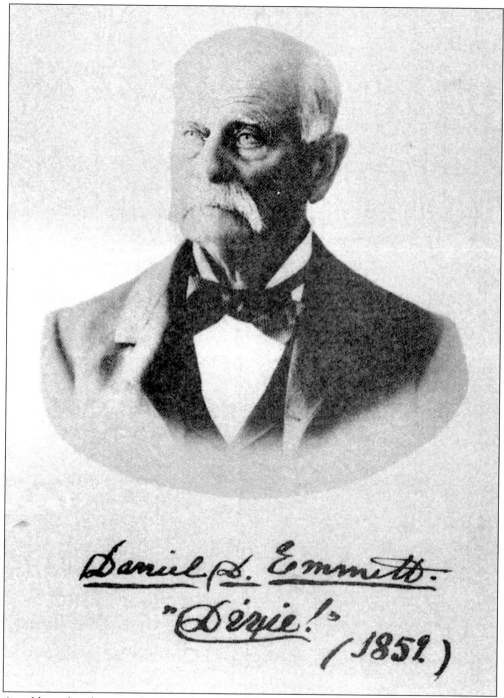

Arnold was bandmaster of a Confederate band during the Civil War, and in 1865, he came to
Memphis to form another band. Arnold remained active as a bandmaster in Memphis for years
to come. He died in 1927 at the age of 89 and is buried along with his wife, Victoria, in Elmwood
Cemetery. Inscribed on Arnold's tombstone is the original "Dixie" musical score.

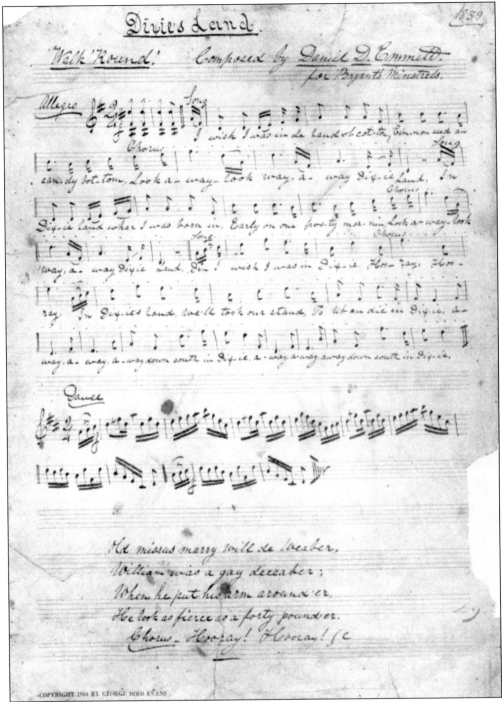

Identified as "the original copy of 'Dixie,'" this single sheet was lent by Daniel Decatur Emmett to be reproduced in the September 1895 issue of *The Confederate Veteran*. The song was first presented by Bryant's Minstrels as "Mr. Dan Emmett's new Plantation Song and Dance Dixie's Land." The following year, Firth, Pond and Company published the first sheet music edition, entitled, "I wish I was in Dixie's Land."

44

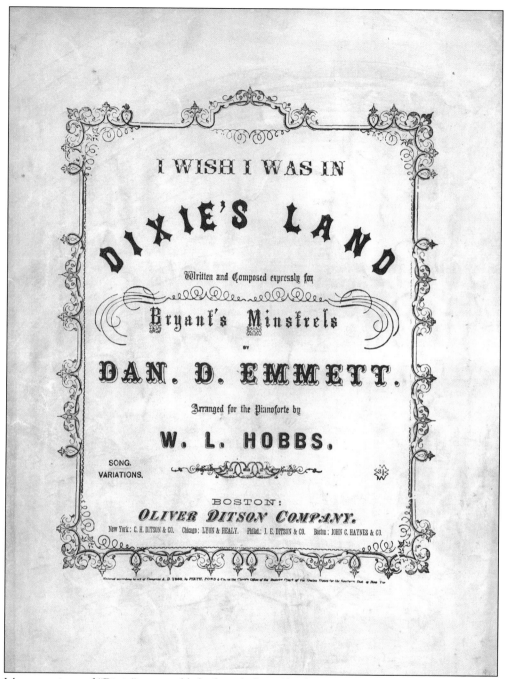

I WISH I WAS IN

DIXIE'S LAND

Written and Composed expressly for

Bryant's Minstrels

BY

DAN. D. EMMETT.

Arranged for the Pianoforte by

W. L. HOBBS.

SONG.
VARIATIONS.

BOSTON:
OLIVER DITSON COMPANY.

New York: C. H. DITSON & CO. Chicago: LYON & HEALY. Philad.: J. E. DITSON & CO. Boston: JOHN C. HAYNES & CO.

Many versions of "Dixie" were published, including Charles Henlein's piano four-hand edition published by E. Witzmann and Company of Memphis.

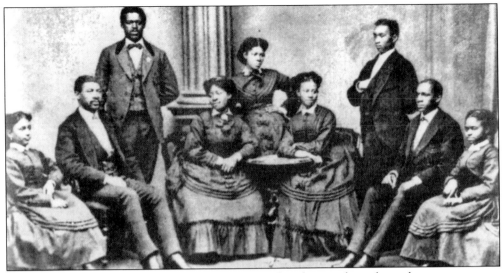

After four years of Civil War, soldiers returned to their homes throughout the war-torn areas of the South. The population of Memphis was once again evolving, as almost 16,000 African Americans now resided in the city. African Americans and Irish competed for living space, and new pockets of living quarters appeared around the city. Many African Americans chose to live in the areas around Linden, Turley, Causey, and St. Martin Streets, as well as one particular street of future music significance, the street named Beale. Returning from the Civil War, two African American residents of Memphis soon became founding members and singers in the original Fisk Jubilee Singers. The four male singers—Greene Evans, Benjamin Holmes, Isaac Dickerson, and Thomas Rutling—had all been born slaves. After the war, Isaac Dickerson came to Memphis, where he found a job at a retail store. There he learned to read and write and attended a local freedman's school. He later taught in an all-black country school and then moved to Nashville to enroll at Fisk. Greene Evans was born near Memphis on a Fayette County plantation. After serving in the war, he returned to Memphis to rejoin his family and two years later enrolled at Fisk. The Jubilee Singers went on to become an international musical sensation.

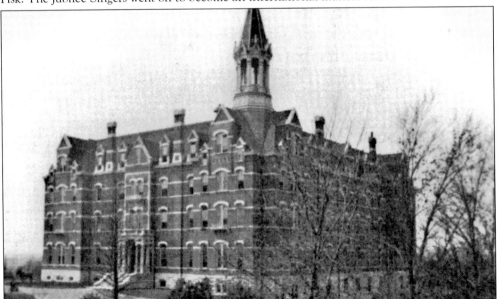

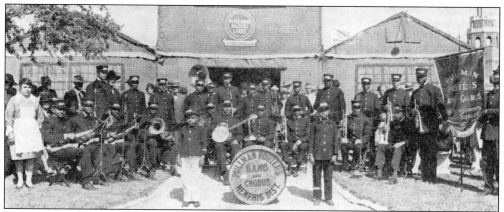

The Fisk Jubilee Singers rocketed to world fame following their appearance at the World Peace Jubilee in Boston in 1872. It was their singing of "The Battle Hymn of the Republic" that caused the stir and established the foundation of the reputation for the singers. By the end of the decade, their concert tour had raised $150,000, enough to erect new buildings on their Nashville campus, including Jubilee Hall (pictured on the opposite page). After Union troops vacated Memphis, the activities of the music organizations resumed and a second philharmonic society was formed. Festivals and celebrations also resumed. A concert was held on the evening of May 16, 1865, at Greenlaw's Opera House, a venue newly built just before the war that had resumed operation in April 1865, addressing the expectations of the cultivated classes of musicians of the city. Greenlaw's was heralded as the finest theater in Memphis. The following account was given in the *Memphis Bulletin*: "Memphis ranks highly than most other American cities for musical cultivations, and the concert last night would compare favorably with any given in the great cities of the north and east." Itinerant opera companies included Memphis on their tour circuit and appeared in the latter half of the 1860s. Grau's German Opera Company, Whitman's English Opera Troupe, the Pati-Strakosch Italian Opera Company, the Isabell McCullough's Troupe, the Ghioni-Susini Italian Opera Troupe, and the Italian Grand Opera Company all appeared at Greenlaw's Opera House to enthusiastic audiences.

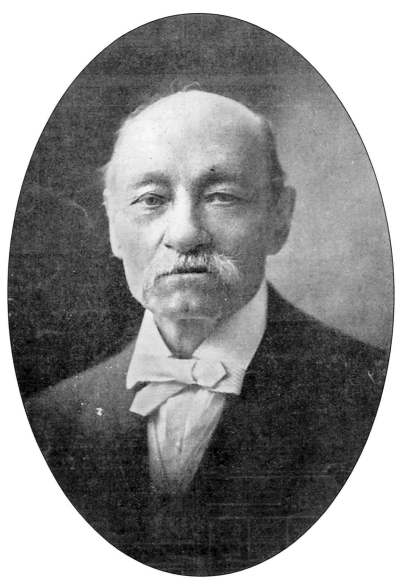

In 1866, Christopher Winkler took over the post of leader of the Mendelssohn Society from Prof. ? Sabatsky. This vocal club, founded in 1865, was hailed as the best-trained and most cultured musicians of the day. Winkler remained in this position until 1870 and was succeeded by Ernest Perring. Winkler also began his long tenure as organist and choir director at St. Peter's Catholic Church in 1866, following the death of Prof. Ben Whaples. Founded in 1840 and located on the corner of Third and Adams Streets, St. Peter's had the finest pipe organ of the day in the city, which served to attract crowds to the church, as did Winkler's compositions and arrangements for the St. Peter's choir. Winkler served as organist-choirmaster at this church through 1901. His impressive choral repertoire there included Mozart's *Twelfth Mass*, Haydn's *Mass No. 2*, Rossini's *Stabat Mater*, and many of Winkler's own compositions. By 1868, the Memphis *Daily Appeal* indicates there was one German school in the city, Madame Platt's German and English School. The newspaper encouraged the German population to support Platt in her efforts through the following notice: "Mrs. Platt is a very enterprising and successful teacher, and deserves encouragement, especially from our German citizens."

Four

AFFLUENCE BRINGS MUSICAL ORGANIZATIONS, ITINERANT ARTISTS, AND EDUCATIONAL INSTITUTIONS

The United States census of 1870 reports the population of Memphis had risen to 40,226, a growth of more than 18,000 people since 1860. Of this population, 3,371 were Irish and 2,144 were German immigrants. An article appeared in the *Cincinnati Courier* in 1870 stating the following:

> On to Tennessee—Everything seems to indicate that the German element of this great republic is finding a new center of gravity. According to uniform reports the German immigration of late is with a decided preference turning toward the State of Tennessee, where, in the more prominent cities, as Memphis, Nashville, Knoxville, Jackson, Murfreesboro, Humboldt, etc., considerable numbers of their countrymen are to be met with already.

Still leading the way musically, on July 4, 1871, Germans resumed the choral work of the Memphis Mannerchor. The society was reorganized by Otto Zimmerman, a Memphis journalist, and within three years, there were over 350 "of the foremost German citizens of Memphis" initiated into the society. In November 1873, they combined with the Memphis Brass Band to present a concert at Cochran Hall as a benefit for the city's German widows and orphans.

Leo Herzog was the leader of the Mozart Society, a group that later inspired a conservatory of music for Memphis, the first of its kind. Christopher Winkler succeeded Herzog, who was then followed by Morse Downs, who had come to Memphis from New York. The Mozart Society was

credited with bringing the various musicians of the city together to work on single projects such as a spring music festival.

Keating characterized the year 1873 as "one of the most eventful in the history of Memphis." His first-hand account of the year described it as remarkable due to the fact that at the opening of the year the city was full of promise. He states, "Nothing could be more hopeful than the outlook at the opening of the year." However, by the end of the year, Keating states, "a commercial panic and epidemics of cholera and yellow fever . . . checked its growth in trade and population." He continues, "The commercial panic was most disastrous in its effects and reached to every part of the Union. Every branch of trade, commerce and manufacturers was affected by it, and many of them completely prostrated." Cholera was announced in early June, and by mid-September, yellow fever had reached epidemic proportions.

One of the many human casualties resulting from the yellow fever epidemic of 1873 was George Frederick von Bruch Sr. Bruch arrived in the United States on September 17, 1867, emigrating from Germany to Memphis along with his wife, Amalie, and his four children.

George Frederick von Bruch Sr. listed "musician" as his occupation on the ship passenger list from Bremen, as did his 18-year-old son Otto. Bruch's younger son, George Frederick Jr., had studied music at the Leipzig Conservatory and was a contemporary there with Edvard Grieg. Along with his son Otto, George Frederick Sr. came to Memphis as a practicing professional musician. After his death, his sons continued to contribute significantly to the musical leadership of Memphis, becoming charter members of the Musician's Protective Union.

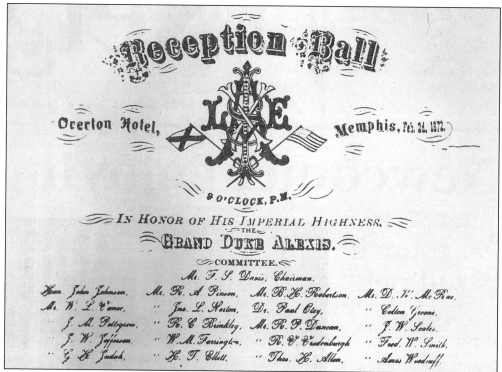

Two significant cultural events started the year of 1872 off with promise. The first took place on February 2 in honor of Grand Duke Alexis of Russia. Grand Duke Alexis was the third son of Czar Alexander II of Russia. He toured the United States in 1872, and on his way to New Orleans down the Mississippi River, he stopped in Memphis for five days. An 11-course meal was prepared, and a ball was held for 400 couples, who danced to the music of Prof. John George Handwerker's 15-piece orchestra.

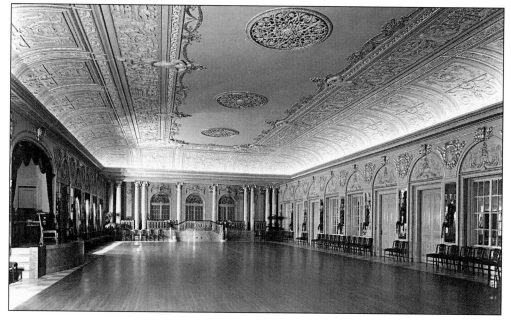

John George Handwerker (1839–1917), leader of this orchestra, was born April 25, 1839. He was the son of Boniface Handwerker, who came to the United States with his wife in 1834. Boniface came to Memphis in 1849 as the first organist at St. Peter Catholic Church and music instructor for St. Agnes Academy. John George Handwerker became the musical director at the New Memphis Theater in 1861 after Carlo Patti vacated the position. John Valentine Handwerker was a pharmacist in the city but also lived out his namesake as a worker with wood.

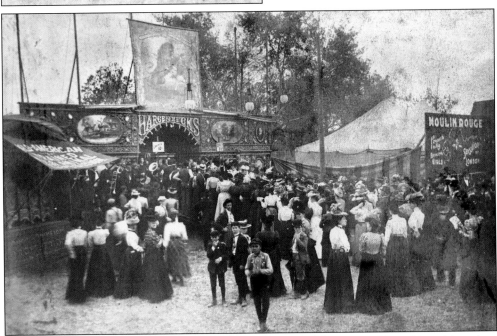

The second social event of 1872 was the first Mardi Gras celebration in Memphis, taking place on February 13. Over 20,000 people attended the festivities. The event witnessed parades, brass bands, floats, tableaux, and masquerade balls that included the best music of the city. Keating states that though it was a spontaneous affair, the first Mardi Gras in Memphis was very successful "and the occasion of much merriment and amusement to thousands of visitors, as well as to the citizens generally."

According to contemporary accounts of this first Memphis Mardi Gras celebration, the line of march was up Charleston Avenue to Adams Street, down Adams to Second Street, up Second to Market Street, down Market to Main Street, down Main to Union Avenue, and finally out Madison Avenue and up Second to Court Square, where the revelers disbanded.

Keating gives a recapitulation of the cultural activities of 1872, mentioning concerts by Memphis favorite Blind Tom, described as "a phenomenal pianist." Keating mentions performances by burlesque actress Lydia Thompson and a lecture by Horace Greeley. Also appearing that year was Bandmann, the "great German artist"; Janauschek; the "renowned Thomas orchestra"; Amie with her French burlesque company; and former resident Carlo Patti, who returned to Memphis to give concerts at the Opera House. The Mendelssohn Society was reorganized in the early 1870s. Their activities included recitals, music memorials, sponsorship of artist concerts, and Mardi Gras processions. Choral concerts were a hallmark of the Mendelssohn Society. Prof. Ernest Perring, organist at Calvary Episcopal Church, conducted a presentation of Handel's *Messiah* in 1874.

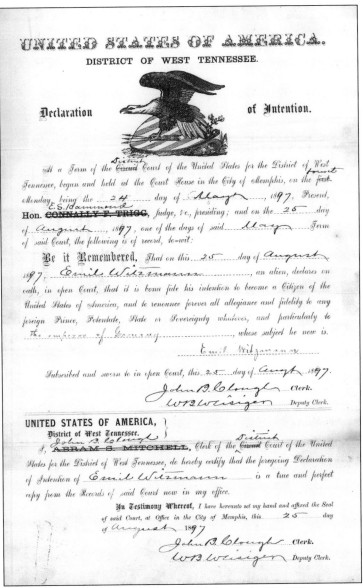

The Memphis *Daily Appeal* reported the following on December 3, 1871:

> Theatrical and musical people regard Memphis as among the first cities in the country. Performers in both arts here are assured of recognition such as few other cities can or do extend. Our people love amusements and are especially wedded to those forms of it in which music is the principal attraction. For that reason the opera is always patronized.

Signs of immigrant assimilation were evident throughout Memphis. In the Jewish community, at a special meeting held on January 22, 1870, the congregation moved from Orthodox toward a Reformed congregation when they voted 28 to 4 to adjust their starting time on Friday evening from just after sunset to 7:30 p.m., a more convenient time for the shopkeepers. At the same time, the members began to let go of their German ways. When asked for instruction on how to lecture during the Friday evening services, the reply was recorded "to do it in the English language."

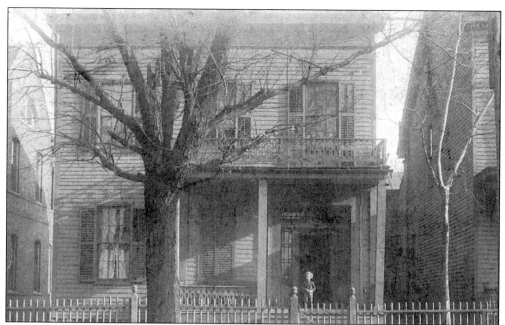

The arrival of Emile Frederick Augustus Witzmann (1841–1914) in Memphis in 1866 was a significant moment in the domestic musical life of the region. The desire for home entertainment and a market for instruments in the home accompanied the growing population and wealth of Memphis. To this end, Witzmann established his retail music and piano store and eventual publishing company in 1872 (his early home is pictured).

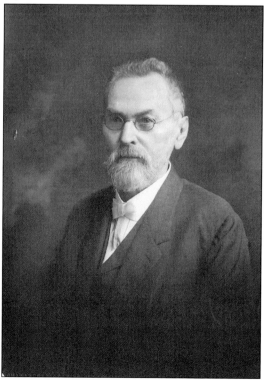

Emile Witzmann was born in Kranichfeld, Germany, August 7, 1841, and left Germany for Paris at 16. Witzmann enrolled at the Sorbonne, where he graduated with honors. He taught music and languages in Paris for six years and relocated to Madrid and then to London, where he met Memphis resident William King, who persuaded him to move to Memphis. He spoke seven languages fluently. Along with his music abilities, he had the skills that would assist him as he established a new life in the growing area of Memphis.

THE

Witzmann

Player
Piano

𝄢

E. WITZMANN & CO.

99-103 N. Second Street

Memphis, Tenn.

Witzmann's first post in Memphis was teaching music and languages at the Armour Institute for Women and the Memphis Female Seminary. He bought used pianos and rented them to his students for instruction. This activity led to his incorporation of a piano business that he opened in 1872 as Seyfert and Witzmann with business partner Henry Seyfert, a fellow music teacher at the Female Seminary. The store was located in the Adams Building on 221 Second Street. The following year, Seyfert left Memphis due to the yellow fever outbreak, leaving the store solely to Witzmann.

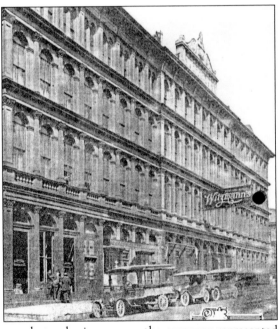

At first, the operation was only a piano store, but as business grew, the company represented "everything musical," as declared in their published advertisements. Witzmann's business took hold while he continued to teach music and languages. Christopher Winkler began working closely with Witzmann in 1872. In 1877, Witzmann added Emile Levy of Little Rock, Arkansas, as a new partner, opening up Arkansas for additional piano business for his company.

In 1873, Memphis received the most devastating blow since the Civil War. Just as recovery was emerging from the setback of the Civil War, yellow fever struck the population. According to Capers, early in August, a ship out of New Orleans docked in Memphis and left two sick passengers behind. Within days, both men died and unleashed the yellow fever into the area. By the end of the month, the city's population of 40,000 had dwindled to 15,000, due to either death or from people vacating the city. Of the 15,000 remaining, 5,000 were stricken by yellow fever, and 2,000 of the sick died.

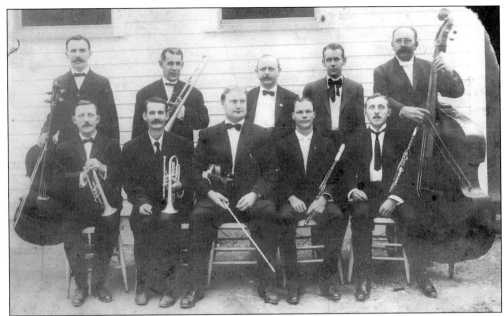

On December 6, 1873, the Musician's Protective Union was formed in Memphis. The strategic location of Memphis as a midway point between New Orleans, Cincinnati, and St. Louis made it the center of river traffic between these terminating river port cities. Orchestras played on board the luxury steamers that traveled up and down the Mississippi River, and Memphis became a recruiting point for large instrumental ensembles. Musicians came to Memphis from all over in search of work on board one of the floating orchestras. The Memphis Musician's Protective Union predated both the AFL-CIO and the American Federation of Musicians by several decades, making it the oldest musicians' organization in America and the nation's oldest existing labor organization.

The constitution for the Memphis Musician's Protective Union was adopted January 4, 1874, and was again revised and amended December 14, 1890, and December 9, 1894. In 1894, the officers included John George Handwerker, president; J. Fischer, vice-president; Otto Bruch, secretary; and Paul Schneider, treasurer. Routine deposits in the treasurer's book indicate the union used the Germania Bank (pictured) for financial transactions.

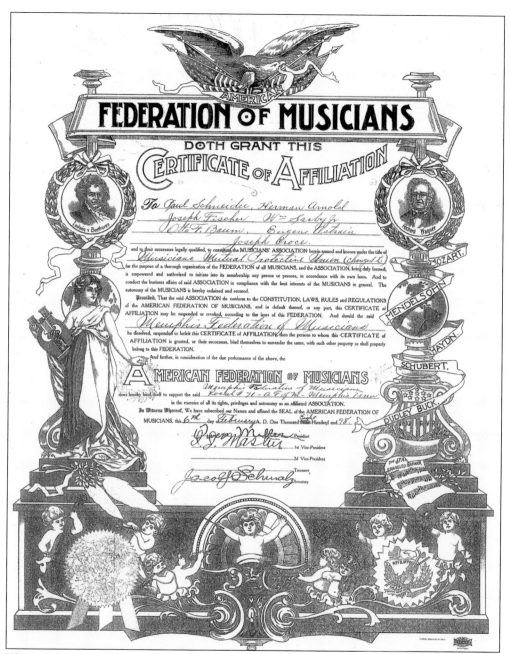

The certificate of affiliation for the Memphis chapter of the American Federation of Musicians is framed by portraits of Ludwig van Beethoven and Richard Wagner and with a streaming banner circling a column containing the sheet music to "The Star Spangled Banner," an American shield of stars and stripes, a globe rotated to the side of North and South America, and a wreath framing the portrait of Richard Wagner. On the banner are the names Mozart, Mendelssohn, Haydn, Schubert, and Dudley Buck.

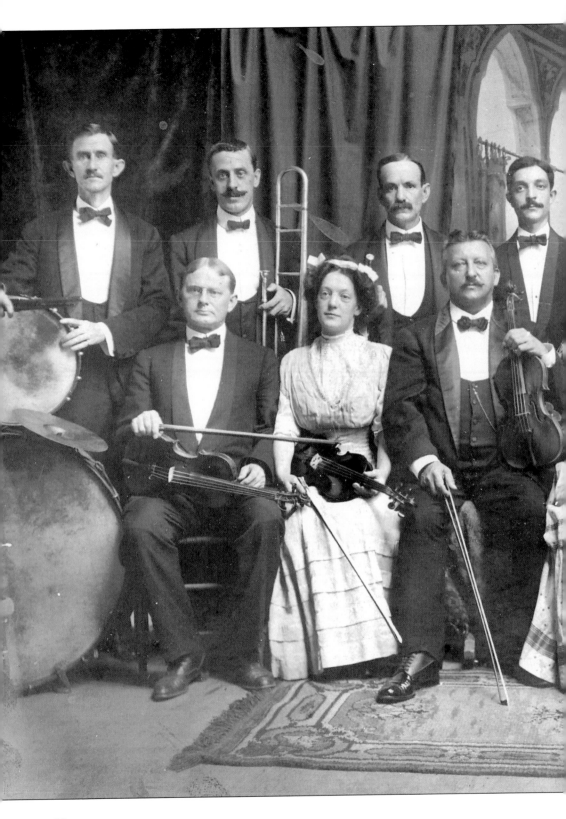

The German Mannerchor continued to present concerts that combined social and cultural goals intended for the enhancement of the greater community. This desire to extend their musical offerings to the entire city continued to be a theme of German musical societies in Memphis. At the close of a year plagued by the yellow fever, a program was presented by the Mannerchor including works by Mendelssohn, Strauss, Schubert, and Wagner. Orchestral performers in the evening concert included Otto Bruch (pictured third from the right in the second row), Frank Arnold Sr., Herman Arnold, M. Meineke, and William Schneider. Prof. ? Siebeck led the singing, and Mannerchor participants included J. E. Luthy, F. Stormer, H. Muer, Theodore Krekel, N. P. C. van Voorhuvsen, L. Wessendorf, A. Goldschmidt, J. Darmstadter, O. Zimmerman, H. Frey, G. Hoffman, A. Zwelfel, S. Langbein, J. Glantzer, H. Detert, and Charlie Mets.

A note printed in the newspaper the next day stated, "We understand that another entertainment will be given by the Mannerchor in about two weeks, and, to judge by the enjoyment afforded those present last night, we may expect a still larger attendance at the next concert." Concerts were performed in concert halls as well as public parks such as Court Square, pictured here.

In the immediate years that followed the city's first of three yellow fever outbreaks, Memphis remained on the verge of panic, always cautious, and economically stagnant. While some businesses such as Witzmann's continued to operate, the city continued to be thwarted from the ingredients that promised to build the arts of the city: population, affluence, and discretionary leisure time. As with the Civil War years, these ingredients were now hard to find.

Five

THE YEARS THE MUSIC DIED

Yellow fever closed the theaters in Memphis in 1873, but they reopened by the winter of that year. Between the years 1873 and 1878, theaters renewed operations, once again offering musical presentations. Opera companies continued to visit the city. Singers such as Adelaide Phillips and Christina Nilsson drew 2,000 people to their concerts. Pianists Anton Rubenstein, Ilma de Nureska, and Teresa Carreño played in Memphis during this era, and the sensations Blind Tom and the Swedish violinist Ole Bull made return visits. Theodore Thomas and his orchestra returned for a performance. Railroads and steamships made Memphis a regular stop on the touring circuit for such performers and ensembles.

The German community of Memphis celebrated the 100th anniversary of the declaration of independence of Mecklenburg County, North Carolina, on May 24, 1875. Tennessee had been a part of North Carolina in its earlier history, and many Germans had come from that area. Germans seized any opportunity to organize civic celebrations. Bands, parades, tableaux, food, and dance were part of these events. The Germans became known for their desire to celebrate, and they were also known for their ability to do it well through music.

Many traveling troupes played in Memphis, but the outstanding event at mid-decade was the appearance for the first time of John Philip Sousa. On October 25, 1875, Sousa came to Memphis conducting for American actor Milton Nobles in a touring company of the play *Bohemians and Detectives*. Sousa wrote "The Bludso March" as an audition piece to convince Nobles to hire him as music director and conductor. Nobles was the orchestra leader at the Washington Street Theater, where the performance took place. Sousa joined the company in Streator, Illinois, in June 1875 and toured with Nobles as far west as Nebraska and then through the South. The tour ended in Washington, D.C., in the winter of 1876. The Memphis performance was part of this tour. The program noted the following important detail: "After the first act of the program the orchestra, under the direction of Prof. J. P. Sousa will perform the *Bludso* march, composed and arranged by J. P. Sousa and dedicated to Mr. Nobles."

This event marks Sousa's first occasion as a conductor. After this event, other bands emerged in the city inspired by the performance, including the Memphis Brass Band, Arnold's Cornet Band, the Christian Brothers College Cornet Band, the Silver Sodality Band, and the Pole Bearers Brass Band.

Churches of Memphis that survived the devastation of the first yellow fever outbreak continued their music activity as a matter of course. Christopher Winkler served a variety of churches around the city. Contemporary accounts nicknamed the song services organized by Winkler at St. Peter's Catholic Church the "dine opera" due to the popularity of these Sunday evening events. Winkler composed a number of pieces for these occasions.

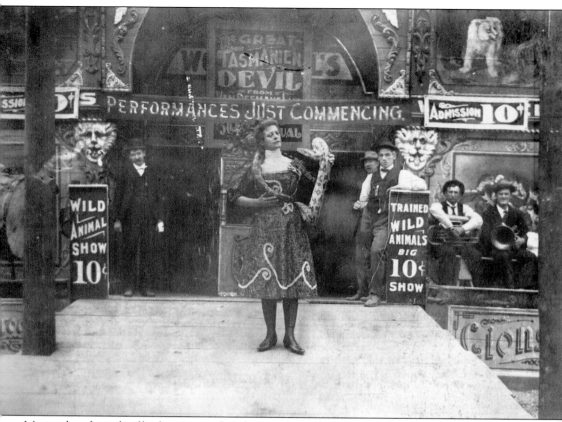

Minstrel and vaudeville shows provided the most popular form of entertainment throughout the 1870s in Memphis, but a cultivated taste continued to grow thanks to the culturally minded music clubs and societies as well as the rise in amateur music making.

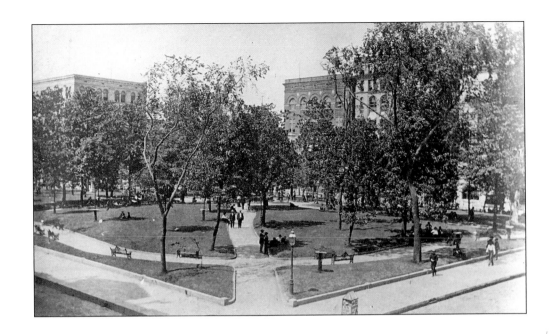

From 1870 through 1880, the German Casino Club sponsored an annual concert, bi-weekly concerts in Court Square, and operas performed by its membership and local musicians. Subscriptions were sold to these concerts, and productions included Mozart's *Don Giovanni*, Beethoven's *Fidelio*, and lesser-known works. Keating reports that the Casino Club had a membership that included the "most enterprising business men of the city."

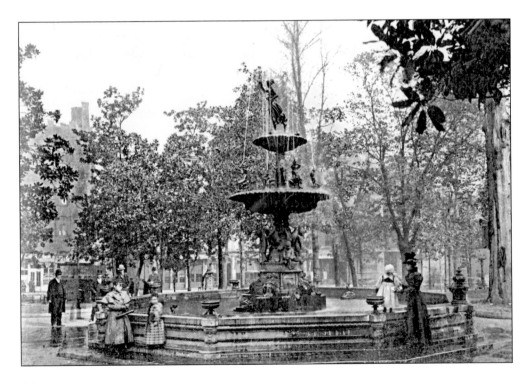

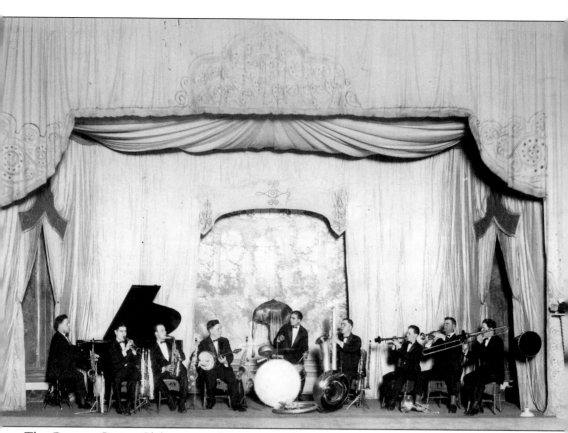

The German Casino Club presented instrumental concerts, including works by Beethoven, Donizetti, Weber, Flotow, Brahms, and Chopin. Professor Schulze formed a group within the club called the Gesangverein that presented choral concerts. Announcing the first Casino concert of the 1875 season, the October 7, 1875, *Daily Appeal* stated the following:

> The first entertainment of the season under the auspices of that most popular organization, the German Casino club, which embraces among the members scores of citizens of all nations and kindreds, came off last night at the clubroom, Cochran hall, and it is superfluous to say that it was a most magnificent success. The Germans have the happy knack of giving entertainments in which the intellectual and the amusing is always combined so that everybody is certain to enjoy the sparkle and esprit with which they are served up.

The concert that evening consisted of a grand military overture, a German chorus, a piece for flute and piano entitled "The Mountaineer's Dance," a comic duet, an "Ave Maria" for alto and piano, a concerto by Legler, and the "celebrated march" from *Tannhauser* performed by Herman Frank Arnold's band. The evening was a success, and the review stated, "The managers of the club are to be congratulated on the success which attended the first of their season's entertainment."

Witzmann's

1872—1919

OUR FOUNDER

Emile Witzmann left Germany when he was 16 years old, even at that time not liking the policy of Government. It must have been a very strong dislike, don't you think, to have caused a boy of 16 to leave his friends, relatives, home and native land never to return and live there again.

He went to London where he became an advanced student and teacher of Languages and Music. Then to Paris as teacher of Languages and Music. After having spent 8 years in London and Paris, he came to America in the fall of 1866 with Mr. Wm. Keen King, an English friend. Both gentlemen came direct to Memphis, likely due to the fact that Mr. King had relatives and interests here.

The manner in which Mr. Witzmann and Mr. King became life long friends is very interesting. After having become good friends in London, Mr. Witzmann returned to Paris as teacher, and Mr. King came to America and then to Memphis. The latter often personally chaperoned abroad groups of boys from this section to complete their education.

Mr. King and his party of boys often times having taught these boys from the Tri-State section. Therefore, Mr. Witzmann had quite an acquaintance throughout the Memphis territory before having decided to come here, and live, and take up his life's work. This is an interesting example of how association and environment may happily shape our destines. After the business had been established for a number of years, one of the many interesting incidents was a visit to the warerooms of E. WITZMANN & CO., of a white-haired, dignified and successful looking gentleman, turning out to be a then large Louisiana planter who had, during his young manhood studied under Mr. Witzmann while in Paris.

After coming to Memphis, Mr. Witzmann became a prominent and successful teacher of Languages and Music for about six years—then fluently speaking seven languages. During this time he purchased used piano offered from time to time by the public and rented them out at a nominal rate per month. This side line, to his then large and prominent class of Music and Language pupils, soon grew, and be added to the small stock of mostly rented instruments, 3 new pianos—this was before a wareroom was acquired or any regular piano business established.

His reputation for honesty and integrity, his knowledge of music and the large acquaintance gave him an excellent natural clientele from which the sale of new and used instruments grew to such proportions that it necessitated a wareroom. The present business was then founded in 1872 at 103 North Second Street in what was known as the Adams building, the first and finest iron front building west of Pittsburg.

In a short space of two or three years, the business convinced Mr. Witzmann that it offered still greater opportunities, therefore, he decided to enter into the piano business permanently, at which time the building at 99 North Second Street was purchased and the business moved next door.

A number of years later the original building in which the business was started at 103 North Second Street was purchased. E. Witzmann & Co., has now grown to such magnitude that it occupies both four story buildings, where may be found complete departments of Reproducing Pianos, Player-Pianos, Pianos, Organs, Talking Machines, Records, Band Instruments, Small Goods, 350,000 copies of sheet music, and, in fact, "Everything Musical."

OUR LINE

The wonderful Ampico Reproducing Piano

New Knabe Grand Pianos
New Knabe Upright Pianos
New Knabe Player-Pianos

New Krakauer Grand Pianos
New Krakauer Upright Pianos
New Krakauer Player-Pianos

New Laffargue Grand Pianos
New Laffargue Upright Pianos
New Laffargue Player-Pianos

New Apollo Player-Pianos
New Schaeffer Harmonolas
New Francis Bacon Player-Pianos

New and used Organs
Used Grand Pianos
Used Upright Pianos
Used Player-Pianos

Brunswick (All in one)
Columbia Grafonola
Used Talking Machines

Sheet Music
Small Goods
Musical Merchandise

Your instrument accepted as part payment on any new Piano, Player-Pianos or Reproducing Piano. Balance, convenient terms. Catalogue of any department upon request.

Visit any department with friends without obligation.

EVERYTHING MUSICAL

Witzmann's PIANOS

EST. 1872

99-103 North Second Street
FORTY-SEVEN YEARS IN MEMPHIS
Home of the Knabe, Krakauer and Laffargue Pianos and Player-Pianos, the Apollo Player-Piano, the Brunswick, the Columbia Grafonola, and the wonderful Ampico Reproducing Piano.

By 1877, the *Memphis City Directory* mentions only two music stores: E. Witzmann and Company and H. G. Hollenberg, also known as the Greater Southwestern Music House. These two firms survived the economic crisis of the first outbreak of yellow fever. Hollenberg remained Witzmann's only retail music competition during this time.

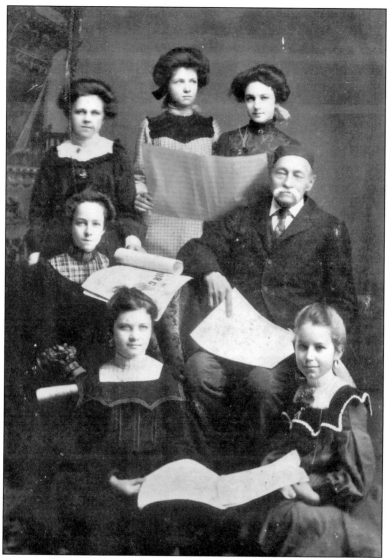

Prominent teachers of music of the era included German professors ? Mueller, Emile Witzmann, Christopher Philip Winkler (pictured above with female students), and Carl von Retter, as well as Mr. and Mrs. De Gray Bennett. Bandleaders included Professors Herman Frank Arnold, John George Handwerker, ? Hessing, and ? Miller. In 1878 and 1879, the second and third outbreaks of the yellow fever disease returned to Memphis with a vengeance. From all accounts, the horrors of the epidemic defy description. However, Keating makes an attempt:

> The epidemic of 1878, the horror of the century, the most soul-harrowing episode in the history of the English-speaking people in America was in full sway. All who could had fled and all were in camp who would go. There were then, it was estimated, about three thousand cases of fever.

The *Memphis Avalanche* described the state of the city during the months of yellow fever with these words: "A sad, weird kind of silence has fallen on the whole city and enveloped it in a mantle so strange and new as to make it appear ghostlike and supernatural."

Deutscher

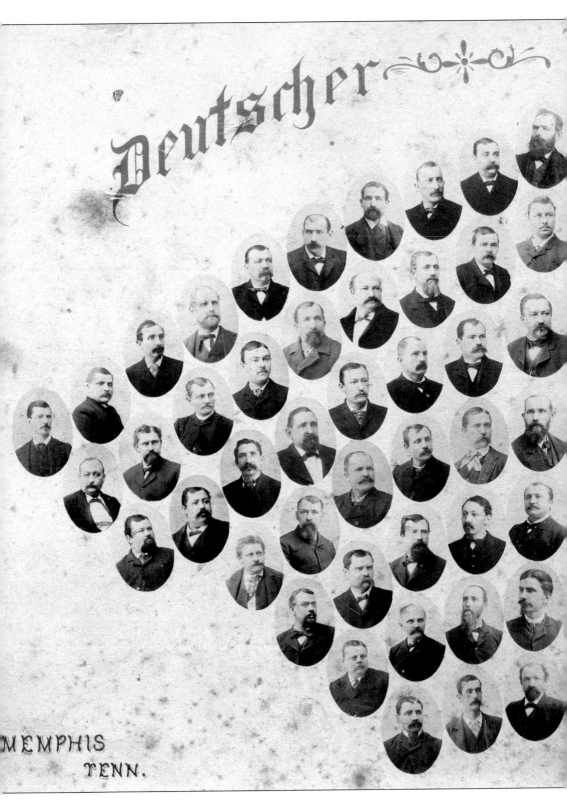

MEMPHIS
TENN.

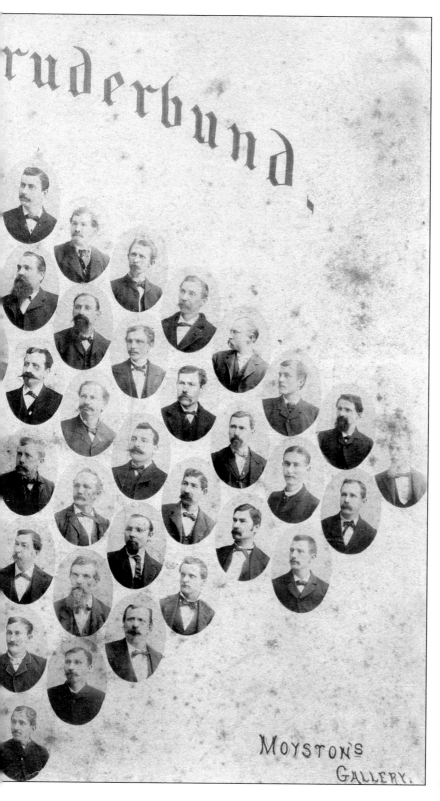

ruderbund

MOYSTON'S
GALLERY.

The German Benevolent Society, founded in 1855 to help less fortunate members of the German community, found its funds critically challenged by the devastation brought by these yellow fever outbreaks. As the need for aid increased, the funds available dwindled to nothing. The Deutscher Bruderbund (German Brotherhood) was organized as a benevolent as well as a social society.

71

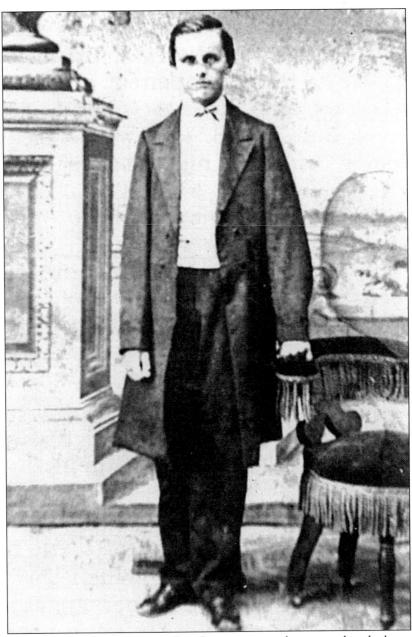

Capers summarizes that the toll of the yellow fever was not only measured in the loss of human life, but also in the loss of good citizens and intelligent contributors to society that moved permanently to other cities: "The migration of Germans was especially serious, since it took from the community an influential group which possessed taste in aesthetic matters as well as sober commercial judgment." Frederick Carl Schaper (1846–1878), born in Liebenburg, Germany, was one of many yellow fever victims. He was a master sergeant in the Union army. Schaper arrived in Memphis in 1862 as part of the occupation forces. He attended services at the German Trinity Lutheran Church, where he met Elizabeth Handwerker, sister of George Handwerker. After the war, Schaper remained in Memphis and became the city's tax collector. He married Elizabeth Handwerker on February 18, 1868.

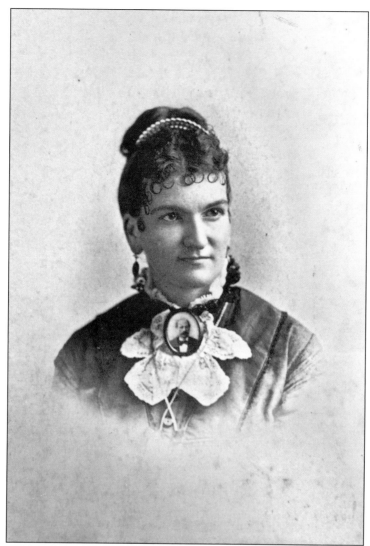

Fred Schaper was a popular figure in Memphis and was elected president of the Memphis German Association in 1877. He led the annual Mai Feste down Main Street in a carriage drawn by four white horses. Schaper formed a small orchestra with other German musicians, playing cello in the ensemble. When yellow fever struck in 1878, he remained in Memphis to help while others fled the city. His eldest daughter, Alice, died with yellow fever on August 30, 1878, and 10 days after her death, Fred got sick; he died on September 10, 1878. His wife, Elizabeth (pictured), wrote the following poem on the loss of her family:

But alas, when that dark night was over,
Followed by a more dreary day,
My kind and loving husband
Lay quietly breathing his life away.
The children watch and call for papa,
They want their good night kiss,
How can I make them understand
That he has gone to that home of bliss.

The September 12, 1878, edition of the *Memphis Avalanche* listed the "Roll of Heroes" who gave their lives for others during the epidemic, including the name of Fred C. Schaper. The only child to survive with Elizabeth was Harry Carl Schaper (pictured), who was also an instrumentalist. Many Germans survived the disease and remained in Memphis after the yellow fever epidemics. Others were safe and alive but in new locations.

Six

PIANO DEALERSHIPS MULTIPLY IN MEMPHIS AS AMATEUR MUSIC MAKING INCREASES

In the early months of 1880, Memphis was recovering from the yellow fever outbreaks of 1878 and 1879. However, optimism was again in the air. An April 13 article in the *Daily Appeal* stated, "The doctors differ in New Orleans as in our own city very materially as to the efficiency of quarantine, and equally as much, as to the origin of yellow fever." The article ended on a note of optimism: "Memphis will grow to wealth and population in spite of epidemics."

Following the yellow fever outbreaks, Memphis experienced a renaissance of musical and artistic activity that grew throughout the next two decades and ushered in the stage for the world-changing music of Memphis in the 20th century. By 1880, nine cultural societies existed in Memphis, all originated by Germans for the encouragement of music and high culture, and not only for Germans, but for the entire community. Bands, concerts, touring artists, opera, and theater were all again flourishing. The German Mai Feste had become an annual occurrence, and the city's celebration of Mardi Gras rivaled the celebration in New Orleans.

Beginning in 1880 and continuing through the new century, the elements of population, affluence, and leisure time for music making provided fertile ground for the rise of an amateur musical class in Memphis heretofore unknown. As signs of affluent times, by 1887, Memphis could list 12 banks, three of which were German owned and operated.

An April 1880 issue of the *Daily Appeal* listed multiple performances of Gilbert and Sullivan's operetta *Pirates of Penzance* and reported that the success of "the recent opera given by the German Casino club . . . has induced them to repeat the opera on the nineteenth instant."

It was in 1880 that Germans in Memphis made the heaviest concerted effort to recruit large numbers of their fellow Germans to the city. An article appeared in the *Daily Appeal* that year announcing that a large number of German citizens were forming an immigration society. At the beginning of the decade, the population of Memphis was 33,000. By the end of the century, the population increased to 102,000.

In addition to schools of instruction, it was the norm to find women teaching music as a profession at home during this era. Piano teaching allowed a woman to stay at home to do her work, linking domestic tasks to professional opportunities. By 1888, the going rate for private music lessons was $12 per month and group instruction cost $6 per month.

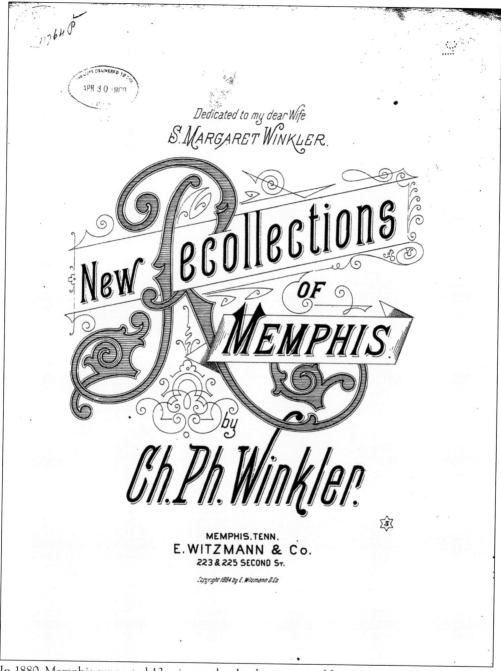

Dedicated to my dear Wife
S. MARGARET WINKLER.

New Recollections OF MEMPHIS

by

Ch. Ph. Winkler.

MEMPHIS. TENN.
E. WITZMANN & Co.
223 & 225 SECOND ST.

Copyright 1884 by E. Witzmann & Co

In 1880, Memphis supported 13 private schools where one could receive music instruction. The popular schools were operated by Clara Conway and Jenny Higbee. Other names associated with schools of music included Florence McCleve, L. J. Searcy, and Julia Hooks. Also making its appearance in the 1880s was the Memphis College of Music, the Memphis School of Fine Arts, and the Memphis Conservatory. Some private music teachers such as Christopher Philip Winkler continued to be associated with music retail establishments as well as publishers such as Witzmann.

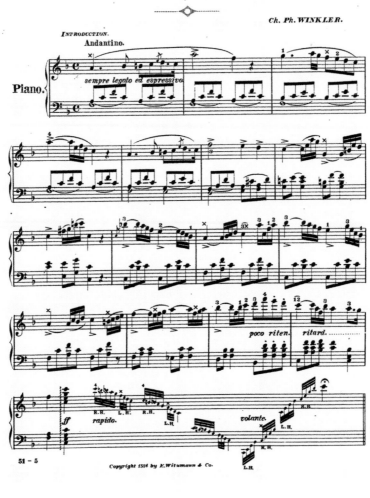

In 1882, the *Memphis City Directory* listed music publishing as one of the new enterprises operated by E. Witzmann and Company. In 1880, Witzmann published the vocal solo by J. Resch and John Rutledge "Sweetheart, Tell Me Why." Throughout the 1880s, the compositions of Christopher Philip Winkler, such as the one pictured here, were published in more rapid succession by E. Witzmann and Company.

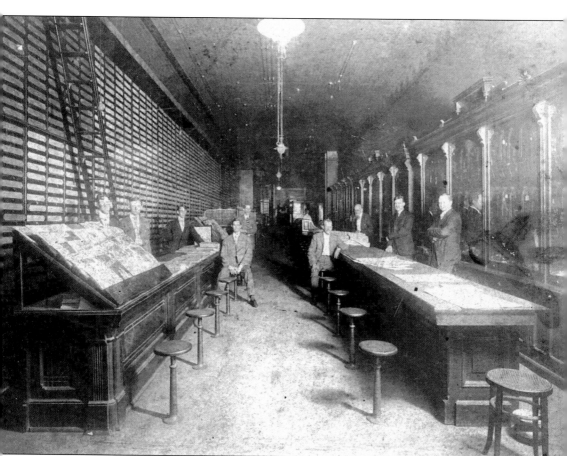

This decade witnessed the explosion of piano sales by Witzmann's piano business. The sale of pianos, piano sheet music publishing, and music instruction were mutually dependent operations. Titles by Winkler published by Witzmann included the *Sabbath Musings* series with the titles "Charity," "Evening Prayer," "Faith," and "Gratitude." Also appearing in print was Winkler's "New Recollections of Memphis." Hundreds of publications carried the E. Witzmann and Company publishing imprint and include original publications of solo piano and vocal works, choral pieces, piano and vocal collections, methods books, and keyboard pedagogical books. A number of commercial retail music enterprises were now open for business in addition to E. Witzmann and Company and H. G. Hollenberg's piano dealership. New piano dealers included O. K. Houck's piano store (pictured) and the music stores of H. G. Getchell, D. H. Baldwin, E. A. Benson, and Jesse French.

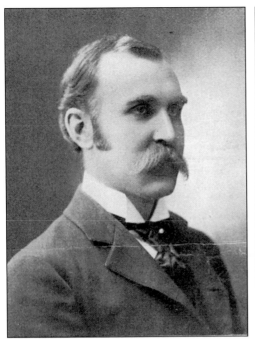 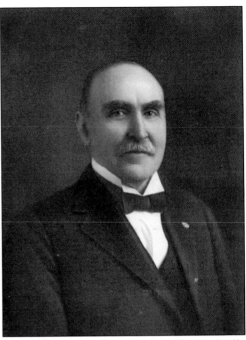

O. K. Houck (above left and right) was born in Decatur, Illinois, in 1862. He moved to Nashville in 1873, attending schools there. With his father, John C. Houck, he established the firm of O. K. Houck and Company at 359 Main Street, Memphis.

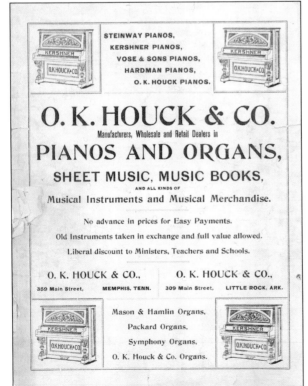

STEINWAY PIANOS,
KERSHNER PIANOS,
VOSE & SONS PIANOS,
HARDMAN PIANOS,
O. K. HOUCK PIANOS.

O. K. HOUCK & CO.

Manufacturers, Wholesale and Retail Dealers in

PIANOS AND ORGANS,

SHEET MUSIC, MUSIC BOOKS,

AND ALL KINDS OF

Musical Instruments and Musical Merchandise.

No advance in prices for Easy Payments.

Old Instruments taken in exchange and full value allowed.

Liberal discount to Ministers, Teachers and Schools.

O. K. HOUCK & CO.,	O. K. HOUCK & CO.,
359 Main Street, MEMPHIS, TENN.	309 Main Street, LITTLE ROCK, ARK.

Mason & Hamlin Organs,
Packard Organs,
Symphony Organs,
O. K. Houck & Co. Organs.

The business prospered from the very beginning, and one year after the establishment of the company, O. K. Houck and Company consolidated with the business of Jesse French of Nashville and the Field-French Company of St. Louis and incorporated under the title of Jesse French Piano and Organ Company. They were a full-service music store and, according to a business journal of the day, carried "every conceivable article coming under the head of Music Merchandise."

E. Witzmann and Company remained the largest piano and music store in the area. Witzmann's sales between 1880 and 1883 totaled almost $100,000. Witzmann handled Laffargue, Knabe, Weber, Wheelock, Kimball, Kranich and Bach, and Mason and Hamlin pianos. For a short period, Witzmann stamped his own company name on generic, low-end pianos that did not carry a label of any kind. The store carried a variety of organs, generally of the small, parlor variety, and the pianos sold were primarily upright parlor pianos. Over the course of its 49-year history, E. Witzmann and Company became the largest piano distributor in the South. The means to own a piano, combined with the leisure time and desire to learn to play the instrument, occurred as a new wave of population came to Memphis. The Industrial Revolution made piano manufacturing a mass-market commodity, as piano keys, hammers, and soundboards were manufactured simply as another part on an assembly line. Witzmann and other businesses capitalized on this growth industry. The average price of a piano in the 1880s was $200, making it within the grasp of many Memphis residents hungry for musical entertainment and with sensitivities and leisure time to pursue the skills necessary to play the instrument. If a piano was too expensive, the reed organ, cabinet organ, Witzmann's "Ampico," or the melodeon at $100 may have been more attractive.

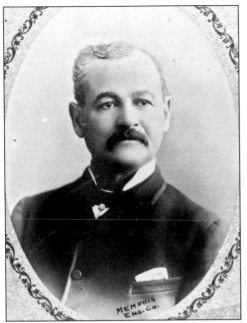

The sales records of E. Witzmann and Company indicate that the family of Robert Church (left), wealthy African Americans who had made money in Memphis real estate, purchased a grand piano as well as a parlor organ from Witzmann, and Mrs. E. H. Crump of Holly Springs, Mississippi, mother of future Memphis mayor E. H. Crump (right), bought a Wheelock upright piano from the store in 1887.

THE VICTROLA BOOK OF THE OPERA

Get this Victrola Book of the Opera

This book tells the stories of over 100 Grand Operas. It tells of the artists and composers, and gives interesting facts not found elsewhere, and a complete list of Operatic records.

To own this book—is to get much more real pleasure out of the Grand Opera Music when you hear it.

Ask Us to Show You a Copy

O. K. HOUCK PIANO CO.

LITTLE ROCK MEMPHIS NASHVILLE

Not only was a piano affordable, it was also part of a proper formal education, particularly for women. A piano in the home signaled good taste, moral superiority, and a certain social distinction of refinement and comfort of life. The discipline of learning to play the piano reflected a good work ethic, an equally attractive attribute in Victorian times. As more and more amateurs played the instrument in the home, a rise in amateur music making created a collective taste for and understanding of musical matters of a higher caliber.

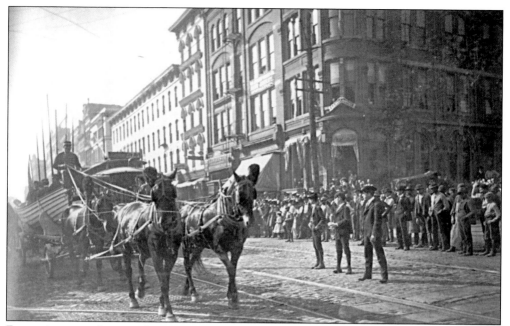

Entertainments of various descriptions increased in appearance throughout the 1880s and 1890s. The strategic railway and waterway location of Memphis practically guaranteed a tour stop by promoters of these concerts and shows, and various music clubs and societies took special care that Memphis was included in tour itineraries.

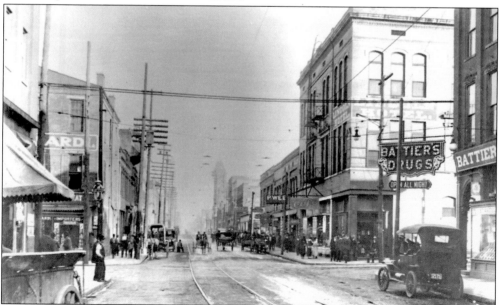

The growth in the number of concert halls, opera houses, hotel ballrooms, and theaters increased during the 1880s as the overall skyline of Memphis itself continued to grow. Memphis now listed Greenlaw's Opera House, the New Memphis Theatre, and Leubrie's Theatre as venue hosts for performers and touring ensembles. Emma Abbott's Grand English Opera Company performed at Leubrie's Theatre in February 1880 to standing-room-only crowds, presenting opera performances of *Romeo and Juliet*, *Faust*, *Il Trovatore*, and *Bohemian Girl*.

Swain's Bijou Cremes

and *BIJOU FACE POWDER*

MADE IN MEMPHIS

By L. S. SWAIN, 771 POLK AVENUE

"Not Better than the Best but Better than the Rest"

"Bijou"
(BE-ZHOO)

MEANS

JEWEL

TRADE

"Bijou"

Reg. U. S. Pat. Office

MARK

A boon to women, and a friend to all of mankind, Swain's Bijou preparations are now leading toilet articles in the South. While their sales have been wonderful, greater results are coming, for, unlike other manufacturers, the Bijou Creme people have held back from new territory owing to an incomplete plant. Now they are ready and, judging from past results, a splendid future is predicted. Their creme has been the subject of deep thought and study. It is analytically pure—harmless and at the same time beneficial to the tenderest skin. It is greaseless—removes sunburn over night, does away with any eruptions due to heat, etc., and cleanses as well as purifies, leaving the skin like satin. Their powder, too, is the very best to be had. Both should find a corner in the traveling bag of every member of the Tennessee Federation and a place on the toilet table in the home. Once tried, always used.

PRICES, 25c and 50c.

For sale by drug stores or sent direct by mail post paid. Send 2c stamp for liberal samples. Try them. Reliable agents wanted everywhere.

Meet me at

Lanier's Merry-Garden Ball Room

on

Monday, Wednesday and Saturday Nights

Open to the Public

Always Enjoyable

Orpheum

The Best of Vaudeville

Memphis' Leading Theatre

Matinees 2:30 Nights 8:30

Prices 75c, 50c, 25c, 10c

LaCreole Hair Dressing

There is not a reason why any one should look prematurely old and gray, for in this day of progress, aside from all other reasons, women who are compelled to mingle in the business world—or in other words—compelled to make their own livelihood, if not the livelihood of others, are forced by circumstances conducive to success to look as well as possible, and prematurely gray hair is certainly not a business asset. The best friend these women have is La Creole Hair Dressing, not a dye, but just what its name implies—a Dressing. Not only harmless, but extremely beneficial to the hair; once used it is ever after to be had among the toilet articles of the well groomed woman. Mail orders given prompt attention.

Van Vleet-Mansfield Drug Co.

Memphis, Tennessee

Page 297

The various music clubs and societies that flourished throughout this era promoted guest pianists, vocalists, and instrumentalists in concert. In November 1881, Rafael Joseffy and Orchestra performed recitals in Memphis, presenting the works of Chopin, Liszt, Mendelssohn, and Schumann. The Abbott opera company appeared in 1882 to equal enthusiasm and again in 1887. Additional opera companies included Memphis on their touring circuit throughout the 1880s, and by all counts, opera was the most popular touring genre to regularly appear.

Seven

MUSIC MAKING IN MEMPHIS COMES OF AGE

Keating's contemporary listing of the various clubs, societies, and cultural organizations in the last quarter of the 19th century provides an encyclopedic survey of Memphis, even listing current members of these organizations. The German Casino grew to be the most sophisticated cultural entity of its kind in Memphis. According to the Memphis *Daily Appeal*, the German Casino included a parlor for women, a reading room, billiard room, dressing room, card room, bar, banquet hall, and dance floor. The casino supported artistic groups within the larger group. These included the Gesangverein and a drama club. The drama club presented operas, while the Gesangverein presented vocal and instrumental concerts.

The purpose of the Memphis Mannerchor, according to Keating, was "to perpetuate German song and the German language, manners and customs." This organization, formed by Christopher Winkler in the early 1860s, renewed its efforts in 1871 and offered entertainment to the community through concerts and operas. With membership over 350, the Mannerchor had the largest number of any German cultural organization.

The Memphis Club was formed in the 1860s and consisted of German and non-German Jews. The elite of the Jewish community formed this organization, which operated closely with the Jewish religious organizations of the city. As with other German cultural organizations, music and theater were a central focus of this society. The Memphis *Daily Appeal* of 1877 reports the existence of a Hebrew glee club, another organization dedicated to choral music.

The Mendelssohn Society began as a male ensemble of four but grew to be known as the Mendelssohn Orchestra, presenting choral works under the leadership of Ernest Perring. This group merged with local church choirs to form the Mozart Society in 1880 under the leadership of Leo Herzog and Christopher Winkler. The group grew from 7 to almost 100 members within a month. By April 1881, the Mozart Society presented a performance of Weber's opera *Der Freischütz*. The *Memphis Avalanche* published the following April 29, 1881, review of the performance:

> The "Wolf's Glen" was especially weird and striking. The burning of the bridge in this scene was so realistic that several people thought the whole set had caught fire by accident, and

were a little panicky for a few minutes. The orchestra was, of course, all that could have been desired, and the baton of Prof. Winkler was wielded with his accustomed skill and judgment. From a musical standpoint the Hunters' chorus of male voices was the gem of the performance—evenly sung, and with admirable spirit and cadence.

According to this review, the house was filled for the performance "by a class of people who really deserved to be designated as intellectual and appreciative." The reviewer added, "The fact that the ladies and gentlemen who took part in the performance succeeded in pleasing this audience, is in itself a very high compliment, and one that a much older organization than the Mozart Society would be proud of." The majority of the cast for this performance consisted of amateurs from the area that had never sung in opera before, which made the production even more remarkable for its smooth and apparently satisfactory execution. According to the newspaper, "The scenery and mechanical effects . . . were by far the best ever seen on stage of the theater for years."

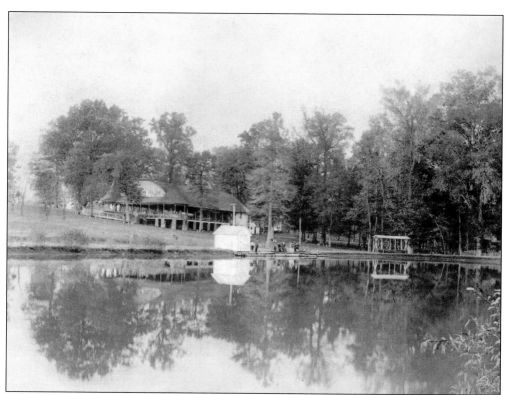

Performances such as that of Weber's opera as well as choral and operetta presentations became the standard for the Mozart Society. Their presentations took place for the most part in Leubrie's Theater, Hollenberg's Hall, or in Festival Park. Another important characteristic of the Mozart Society concert offerings began to take shape—the presentation of new music to the community. The first music festival in Memphis was sponsored by the Mozart Society and took place in the spring of 1883.

In 1883, Julia Hooks and Anna Church, spouse of African American businessman Robert Church, formed the Liszt-Mullard Club. The purpose of this society of women (some of whom are pictured here), similar to other musical societies that had organized in Memphis, was to promote classical music and to raise money to scholarship the musical training of young musicians. The Liszt-Mullard Club also performed classical music concerts in the city during the 1880s. The Liszt-Mullard Club was the first African American organization in Memphis devoted entirely to music.

Julia Hooks (1852–1942) was a prominent musician of color as well as one of the pioneer social workers of Memphis. In 1869, she attended school at Berea College, where she advanced her musical training. From 1870 to 1872, she was listed as the faculty instructor of instrumental music at Berea, making her one of the first African American professors to teach white students in Kentucky.

In 1872, Julia moved to Greenville, Mississippi, to marry Sam Werles, a schoolteacher there. During the yellow fever epidemic of 1873, Sam caught the fever and died. Julia then moved to Memphis and began teaching school in 1876. Four years later, she married Charles Hooks, a former slave.

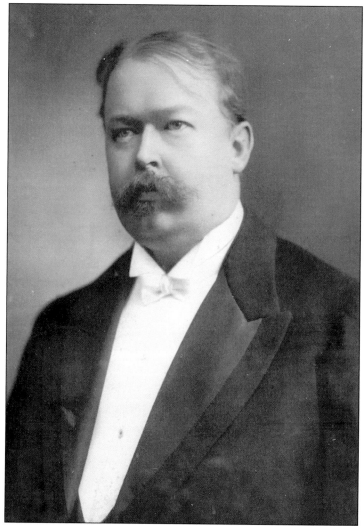

Morse Downes of New York followed Winkler as musical director of the Mozart Society, and a committee of businessmen managed the financial affairs of the society. The Mozart Society continued to evolve, becoming the Choral Society and back again to the Mozart Society by the early 1900s. The Mozart Society's conservatory was later the progenitor of the Theodor Bohlmann School of Music. Bohlmann was a renowned German pianist who had made his debut with the Berlin Philharmonic Orchestra in March 1888. After making a tour of Germany, Bohlmann came to the Cincinnati Conservatory at the height of his career and established his reputation as one of the leading American pianists, pedagogues, and lecturers on music. Bohlmann left Cincinnati to come to Memphis, where he established his own school of music. The Theodor Bohlmann School of Music later became the Memphis School of Music. This school merged with Southwestern at Memphis, the liberal arts college that became Rhodes College. The next musical society to enter the stream of organizations defined by the name of a German composer was the Wagner Club, forming in 1888. The Wagner Club was dedicated to the performance of instrumental music. Prof. Emile Levy, a partner in the retail music trade with Emile Witzmann, was a founding member of the Wagner Club. He served as director of the organization and was a champion for the works of Wagner and other vocal composers. The Wagner Club remained in existence two years and continued to produce impressive programs and attract large audiences to their concerts.

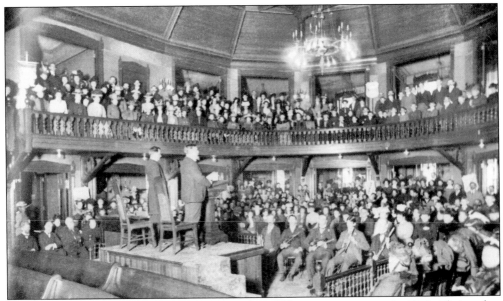

First Presbyterian Church acquired a new Hook and Hastings pipe organ in 1888. Christopher Winkler organized a concert to demonstrate the versatility of the new instrument. The concert included the "Overture to Samurais," "Trumperies-Reverie," "Memphis March," "Prayer and Triumphal March," and the singing of the "Kyrie" from Mozart's *Twelfth Mass*. Even more refined in musical purpose and prowess were the music clubs that took the name of German composers. These performance organizations bore the club names of Mozart, Mendelssohn, Schubert, and Wagner. These were the names of the ruling German composers of Europe at the beginning of the 19th century and well into the time when Germans were immigrating to the United States.

On the afternoon of October 27, 1888, a music society was formed that was to outlast and out-influence all of the rest. Martha Trudeau (pictured) hosted a tea in her home to organize a new music society. The new group called itself the Beethoven Club. The new club sponsored guest artists in concerts similar to the activities of the other clubs that had formed earlier. This club was to be different, however; the Beethoven Club would outlast all the other music societies of its kind in Memphis, continuing its mission and membership to the present day.

Eight

NO TURNING BACK

By 1890, the population of Memphis was 64,000, and interest in music as well as the number of music societies in Memphis was at an unprecedented high level. There was activity in every genre of music performance, and while choral ensembles remained at the heart of the musical culture of the city, the 1890s gave rise to new instrumental societies as well as the continuation and hunger for opera, theater, and concert chamber music.

In an article published by the *Commercial Appeal* in 1890, Christopher Winkler wrote the following assessment of the musical scene in Memphis, signaling instrumental events that would soon unfold:

> We have at the present time better orchestra facilities than at any time since 1878, and by using the orchestra here as a nucleus and bringing performers on such instruments as are not here (such as oboe, bassoon, etc.) we could perform the orchestra parts of any opera or oratorio.

In 1890, Mary Lou Bulling and Nettle L. Musser, just recently returned from several years of music study in Berlin, set up their music studio in Memphis known as the Bulling-Musser School of Music.

In August 1894, the Philharmonic Club, first called the Philharmonic Quintette Club, came into being, consisting of a string quintet and piano. The Philharmonic Orchestral Association, a completely different organization, formed in 1893 as the result of a group of amateur musicians desiring to improve and enjoy leisure hours in musical pursuits. The Philharmonic Club, on the other hand, was dedicated solely to the study and performance of chamber music. The following review of a chamber recital performed in Witzmann Hall appeared in the March 30, 1895, *Commercial Appeal*:

> An enthusiastic little gathering of Memphis music lovers was given a rare treat of chamber music by the Philharmonic Quintets Club at Witzmann Hall last night. The hit of the

evening was the *Ave Maria* from Mascagni's *Cavalier Rusticana*, the bright particular gem of the opera that made the young Italian composer famous.

The Mascagni aria mentioned had premiered only five years earlier in Rome on May 17, 1890.

The Philharmonic Orchestral Association continued to grow and improve. Prof. George Frederick von Bruch directed rehearsals and added musicians to the roster. Bruch became one of Memphis's most venerable musicians.

In 1885, John Schorr arrived in Memphis from Nuremburg, Germany, and opened his Tennessee Brewing Company. By 1900, the Tennessee Brewing Company was producing 250,000 barrels of beer annually. Also in the 1880s, Charles Dinstuhl left Germany and moved to Memphis, starting a small candy business next door to his Theotorium, one of the city's first movie theaters. Dinstuhl's Candies is still a German landmark and destination in Memphis today.

A new theater, the Lyceum, was built in the year 1890 at the corner of Third Street and Union Avenue. The Lyceum burned in 1893 and was replaced in 1894 by a new theater at Second Street and Jefferson Avenue. As concert halls were built, the new decade welcomed new musical clubs to the growing list of societies in Memphis. The Apollo Club sponsored public concerts such as Handel's *Messiah* and Haydn's *Creation*. The Memphis Select Choir originated in 1894 and was led by Prof. ? Bernhard. This choral group presented part songs, excerpts from oratorios and operas, and cantatas, as well as vocal and instrumental chamber music.

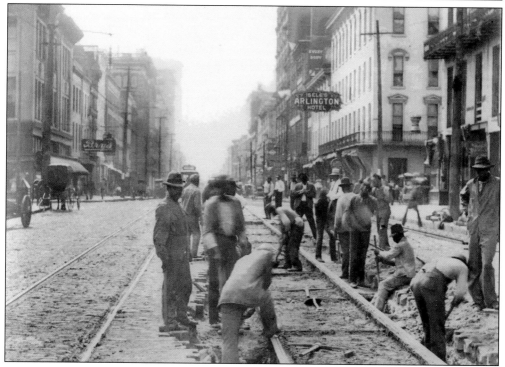

Julia Hooks, who organized the first African American music society in Memphis, the Liszt-Mullard Club, in the 1880s established the integrated Hooks School of Music in Church's Auditorium. Among her piano students were Roberta Church, Sidney Woodward, and Nell Hunter. Her best-known student, however, was the student she instructed in music theory, W. C. Handy. Hooks led in the musical direction of churches in Memphis as organist and choir director throughout these years, later serving as schoolteacher and principal. Julia Hooks is affectionately remembered as "the Angel of Beale Street." The expansion of piano sales took new proportions between 1890 and 1910. In a comparison of eras, from 1870 to 1890, piano manufacturing multiplied only 1.6 times as fast as the population, but that increased to more than 5.6 times the population growth rate between 1890 and 1900, and the rate was 6.2 times as high as the population growth from 1900 to 1910. As piano popularity increased, the need for sales and distribution expanded. Similarly, the home organ business grew.

Emile Witzmann's piano business kept pace with this trend in sales. He gained the reputation as the premier piano dealer in the South. The growing market for pianos and other musical instruments provided ongoing retail competition for musical trade. Hollenberg's piano store was the exclusive dealer for the Chickering piano, a piano that differed in tone and action from German-inspired pianos. Hollenberg and Witzmann emerged from the yellow fever years as retail musical survivors, but a growing population and a growing taste and desire for making music in the home brought more business to the expanding piano dealers of Memphis. By 1887, the *Memphis City Directory* lists additional piano dealers including Baldwin and Company and Houck's company, which became the exclusive Steinway dealer. In 1891, Witzmann bought out retail partner Emily Levy for a sum of $1,650, dissolving their partnership. The sales records of the E. Witzmann and Company piano store reveal that in 1890, the store sold 223 pianos and organs. Ten years later, in 1900, the total sales for the year were 380 keyboard instruments. By 1903, the store had reached an annual level of sales of almost 425 instruments.

On September 30, 1890, the Grand Opera House opened on the corner of Main Street and Union Avenue. The appetite for opera continued in Memphis, and opera companies regularly toured to the city. The Teary Opera performed Wagner's *Lohengrin* at the Lyceum Theater, and other companies presented *Lucia di Lammermoor*, *Les Huguenots*, *Tannhauser*, and *Cavaleria Rusticana*. In 1897, New York's Metropolitan Opera came to Memphis performing *The Black Hussar*, and in 1899, the Lombardi Royal Italian Opera Company performed in Memphis.

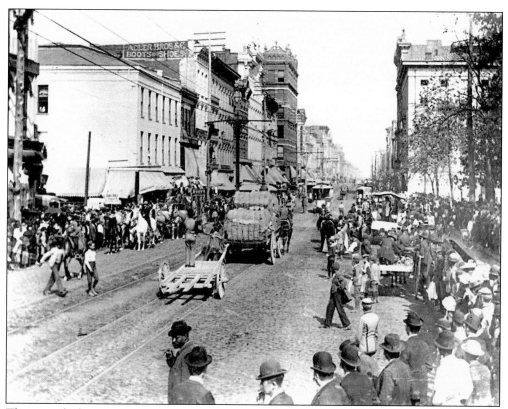

This period of prosperity gave rise to a flourishing arts district on Beale Street. An opera house was built at the corner of Beale and Main Streets that hosted touring companies throughout the year (later the Orpheum Theater). The Lincoln Theater opened on Beale Street, the first theater established in Memphis by African Americans. The Beale Street of 1890 was a diversified district in every way: black and white businesses; opera house and burlesque theater; churches and brothels; restaurants and saloons; mansions and shacks; parks and gambling rooms. It was in this urban mix that W. C. Handy arrived to write his songs, form his company, and create the distinction that would bring lasting notoriety to Memphis.

Music of all descriptions converged on Beale Street: opera, symphony orchestra, brass band, burlesque and minstrel show, rag, gospel, spiritual, and the musical groans and hollers that found a name and form in the blues. It was here that W. C. Handy first heard the ragtime "piano thumpers" in the late 1880s, and it was here that he would write the "Memphis Blues," giving the country a new musical name and genre on which to build. In a foreword that he wrote in 1934 to George W. Lee's book *Beale Street: Where the Blues Began*, Handy offers the following poetic reflections:

> If I were an artist I would long ago have given to the world a painting, expressive of my emotions, when as a small boy on a visit to Memphis, I first saw the Beale Street Baptist Church, with the hand of John the Baptist pointing heavenward, enveloped in snowflakes from a gray sky. Lacking that talent I have used my God-given talent to paint a "word picture" in song, of a street that to me represents more of interest than any other such thoroughfare I have ever seen.

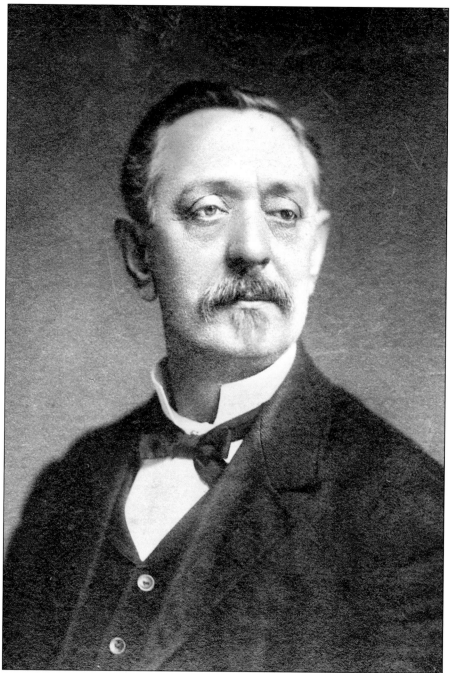

George Frederick Bruch (1852–1940) taught music, performed on flute and violin, and conducted the early Memphis Philharmonic Orchestra in the 1890s. This ensemble was the resident orchestra at the Grand Opera House on the corner of Main and Beale Streets, later the site of the Orpheum Theater. In his early years, Bruch was a member of the Lyceum Orchestra, which had welcomed John Philip Sousa on the occasion of Sousa's first visit to Memphis. Bruch taught many of the prominent vocal and instrumental musicians of Memphis and in 1873 was one of the founding members, along with his brother, Otto, of the Musician's Protective Union.

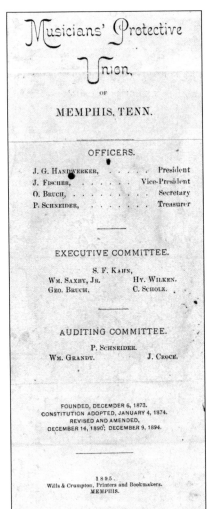

Musicians' Protective
Union,
OF
MEMPHIS, TENN.

OFFICERS.

J. G. HANDWERKER, President
J. FISCHER, Vice-President
O. BRUCH, Secretary
P. SCHNEIDER, Treasurer

EXECUTIVE COMMITTEE.

S. F. KAHN,
WM. SAXBY, JR. HY. WILKEN.
GEO. BRUCH. C. SCHOLZ.

AUDITING COMMITTEE.

P. SCHNEIDER.
WM. GRANDT. J. CROCE.

FOUNDED, DECEMBER 6, 1873.
CONSTITUTION ADOPTED, JANUARY 4, 1874.
REVISED AND AMENDED,
DECEMBER 14, 1890; DECEMBER 9, 1894.

1895.
Wills & Crumpton, Printers and Bookmakers.
MEMPHIS.

The treasurer's book of the Musician's Protective Union contains a printed frontispiece on the inside cover that lists "Geo. Bruch" as a part of the executive committee of the organization in 1895. Along with Bruch's name appears S. F. Kahn, William Saxby Jr., Hv. Wilken, and C. Scholz. The officers included Otto Bruch, secretary; John George Handwerker, president; J. Fisher, vice president, and Paul Schneider, treasurer.

In 1898, George Frederick Bruch had become treasurer of the union, continuing in this office through 1910, where in his pen he lists the account credits followed by the words "Resigned Jan 1st, 1910." Bruch retired in 1930, having gone blind around 1914. Bruch's son Lester directed the Works Projects Administration as supervisor for West Tennessee, and his grandson Lester Jr. was a popular jazz musician in the 1940s. Bruch's other grandson, Donald, remained in the Memphis area and played piano as an avocation.

William Saxby, also a member of the Executive Committee of the Musician's Protective Union, was born in Ohio. Saxby moved south and joined the Confederate army during the Civil War, and in the late 1860s, he moved to Memphis, where he worked as a professional musician and dance instructor. He organized a band and was a director of the Philharmonic Orchestra in the mid-1890s. He organized and directed the official municipal band of Memphis, which played at the city's most important ceremonies. His band gave Sunday concerts at various parks throughout the summer months with programs varying from high classical selections to ragtime.

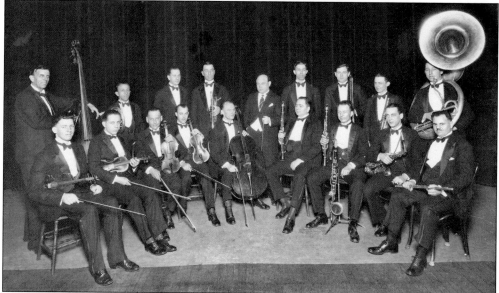

As the decade progressed, the Philharmonic Orchestral Association outgrew its amateur status and was on track to build a professional orchestra, inspired by what it had seen happen with the St. Louis Symphony Society Orchestra. The Memphis ensemble had 40 players and was on its way to a more serious complexion. A program by the Philharmonic Orchestral Association in 1896 consisted of repertoire by Strauss, Meyerbeer, Verdi, Bizet, and the popular American composer John Philip Sousa.

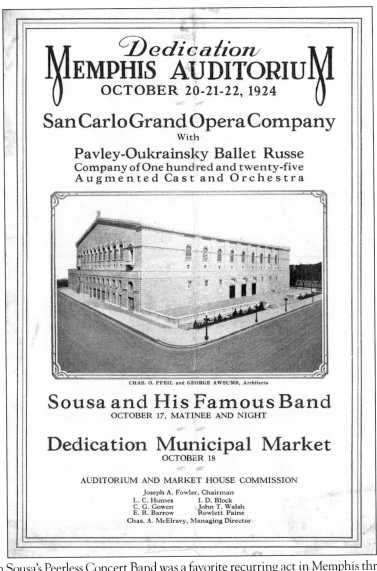

Dedication
MEMPHIS AUDITORIUM
OCTOBER 20-21-22, 1924

San Carlo Grand Opera Company
With

Pavley-Oukrainsky Ballet Russe
Company of One hundred and twenty-five
Augmented Cast and Orchestra

CHAS. O. PFEIL and GEORGE AWSUMB, Architects

Sousa and His Famous Band
OCTOBER 17, MATINEE AND NIGHT

Dedication Municipal Market
OCTOBER 18

AUDITORIUM AND MARKET HOUSE COMMISSION

Joseph A. Fowler, Chairman

L. C. Humes	I. D. Block
C. G. Gowen	John T. Walsh
E. R. Barrow	Rowlett Paine

Chas. A. McElravy, Managing Director

John Philip Sousa's Peerless Concert Band was a favorite recurring act in Memphis throughout the 1990s. An advertisement in the May 1, 1895, *Commercial Appeal* for Sousa's concert promised 50 musicians, great vocal artists, and a magnificent program that included inspiring marches as encores. Sousa never failed to deliver what was promised. In 1896, Ignace Paderewski, the internationally acclaimed concert pianist, appeared in Memphis, performing on the evening of January 29 at the Grand Opera House. His program included Brahms's Variations and Fugue on a Theme by Handel; Beethoven's Sonata in D Minor, Op. 31, No. 2; Chopin's Nocturne in G Major, Op. 37, No. 2; Chopin Etudes Nos. 6, 7, 8, and 9; Paderewski's Craco-vienne Fantastiques, Op. 14, No. 6; and Liszt's Etude de Concert, No. 2 and Rhapsodie, No. 12; along with other works. The reviewer recorded the following reactions to the performance in the January 26, 1896, *Memphis Figaro*:

> There is a charm in Paderewski's playing so subtle that it evades analysis. He handles the works of others as if they were creatures of his own, giving them an individual reading, yet preserving a marked loyalty to the composer. He will magnify an etude into a triumphant march, yet it will remain a "study" of its composer.

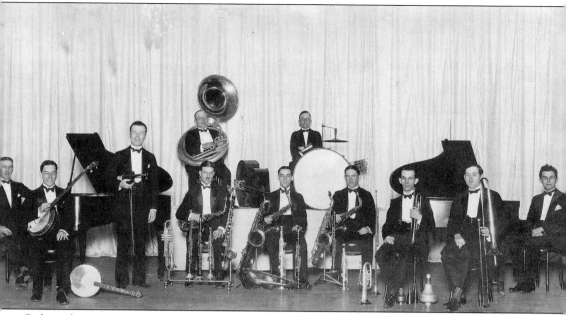

Paderewski's reputation had been fueled by his introduction to American audiences by the Steinway piano company in 1891. No pianist had captured the attention of the American imagination as had Paderewski, who continued to please audiences for 30 years. He was a Steinway artist, playing and promoting the Steinway name throughout his career. By 1897, Memphis could boast of at least nine bands and orchestras, such as the one pictured above. The *Memphis City Directory* of that year includes the Lyceum Theatre Orchestra, conducted by Herman Arnold; the Grand Opera House Orchestra, conducted by John George Handwerker; Arnold's Orchestra and Band; the Croce Brothers String Band; the Christian Brothers College Band; Kahn's Military Band and Orchestra; the Chickasaw Cornet Band; Hall and Turner's Orchestra; the Young Men's Union Association Band and Orchestra; and a variety of brass bands.

The Beethoven Club continued their leadership role in bringing the best concerts and artists to Memphis throughout the 1890s. This club took over what earlier German-inspired music clubs and societies had done for the city, exerting an ongoing cultural influence through numerous concerts, sponsorship of opera companies, touring artists such as Ignace Paderewski, chamber music

presentations, and return engagements of John Philip Sousa. The music societies that had furthered the cause of great music in Memphis such as the Mozart, Mendelssohn, and Wagner Clubs faded, but the Beethoven Club continued to provide innovative leadership into the next century. One of its new and forward-thinking initiatives was the formation of a Junior Beethoven Club.

In 1892, the Beethoven Club created a charter that defined the organization exclusively as a women's club. One of the broad purposes of the Beethoven Club was the stimulation of musical interest on the part of the citizens of Memphis. This purpose took the shape of the sponsorship of an annual concert series featuring guest artists from around the country. The first concert sponsored by the new Beethoven Club featured members of the club along with guest artist William H. Sherwood, a pianist from Chicago. Sherwood played the works of Joseph Rheinberger and Franz Liszt, and the review was favorable. In the years that followed, the "Beethovens," as they were nicknamed, brought a great variety of artists to the city to the delight of their growing audiences. In January 1894, the Beethoven Club sponsored their first large ensemble featuring a return to Memphis of the Theodore Thomas Orchestra. The program by Thomas's full orchestra included "Three Marches," Op. 40 by Schubert, Dvorak's "Slavonic Rhapsody," No. 2, and works by Wagner, Tchaikovsky, Servais, and Moszkowski. More large-scale concerts followed throughout the 1890s, including opera companies and a variety of solo artists. Enthusiasm for the Beethoven Club and the ongoing success of their mission continued to mount. From 1894 to 1900, the Beethoven Club presented three to six guest artists annually, consistently receiving praise for the high quality and variety of their programs. This would become the pattern for this enduring society for the century to come. The Junior Beethoven Club was formed in the summer of 1899 for boys and girls from age 10 to 18. The first president of the Junior Club was Mrs. Napoleon Hill (above). The purpose of the Junior Club was for the presentation of musical programs and for the study of the finest in classical music on the part of children. By 1912, the Junior Beethoven Club had over 100 members and was sponsoring significant public concerts. It is credited as the first federated music club for children in the United States.

Nine

THE BLUES COMES TO TOWN

By the beginning of the 20th century, a crossroad could be identified in Memphis where the path of preparation intersected the path of opportunity. The two roads had been moving closer together for half a century only to encounter roadblocks in the form of war and disease. However, it was now clear that the roads were finally at their point of intersection. The preparation path had weathered the bad times and was primed for something better than survival, and opportunity now took the path of optimism, affluence, and a sense that Memphis was coming of age. The city had reached a population of 102,000.

Green P. Hamilton (1867–1932) organized the first African American high school band at Kortrecht High School (later Booker T. Washington High School) around 1900. Hamilton was born in Memphis in 1867, and in 1882, he graduated with honors from Lemoyne Normal Institute. He completed his schooling at Rust College in Holly Springs, Mississippi, and Columbia University in New York.

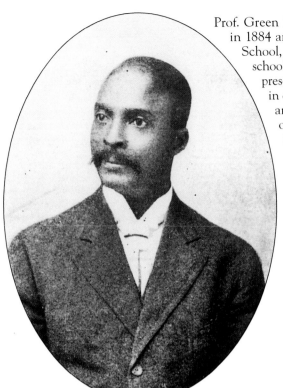

Prof. Green Hamilton began teaching in Memphis in 1884 and became principal of Kortrecht High School, the first African American public high school in the city, in 1892. The Kortrecht band presented a benefit concert at Church's Park in order to raise funds to purchase uniforms and instruments. A. L. Hall, M.D., who owned the African American *Memphis Striker* newspaper, raised the balance of the needed $900 for the uniforms, and the band went on to become a success, touring Mississippi and Arkansas and presenting concerts in the larger cities of the region.

The African American community continued to grow in musical sophistication. In addition to Julia Hooks and Green Hamilton, Lucie Campbell (1885–1963) contributed to the musical life of Memphis. Campbell (pictured) was born in 1885 in Duck Hill, Mississippi. Her mother, Isabella, not only wanted her children to receive an education, she also wanted them exposed to the arts. She gave piano lessons to Lora, Lucie's older sister. While piano lessons were being given to Lora, Lucie listened attentively and practiced the lessons on her own.

Lucie went to school in Memphis. In 1899, she graduated from Kortrecht High School as valedictorian and was awarded the highest prize for her Latin proficiency. After completing high school, Lucie passed the teachers' exam and began her teaching career at Carnes Avenue Grammar School. In 1911, she was transferred to Kortrecht High School, where she taught American history and English. Later she earned a baccalaureate degree from Rust College in Holly Springs, Mississippi, and a master's degree from Tennessee Agricultural and Industrial State College. Campbell learned piano from her mother but for the most part was a self-taught musician. She was a contralto singer and played the organ and piano at the Metropolitan Baptist Church in Memphis. At the age of 19, Campbell organized a group of Beale Street musicians into the Music Club, a local affiliate of the National Federation of Colored Musicians. In 1909, she began teaching the young people's choirs at church. She formed a thousand-voice choir that performed at the National Baptist Convention. At the organizational meeting of the National Sunday School and Baptist Young People's Union Congress of the National Baptist Convention held in Memphis in 1915, Campbell was elected music director. She penned songs for the congress and wrote musical pageants such as *Ethiopia at the Bar of Justice*. This musical position was an influential leadership role for black Baptist churches throughout the country. As head of the music committee that compiled hymn and song books for her denomination, Campbell helped create the song book compilations *Golden Gems*, *Inspirational Melodies*, *Spirituals Triumphant*, and *Gospel Pearls*. Her song compositions include "Something Within," "He Understands," "He'll Say 'Well Done,'" "Heavenly Sunshine," and "The King's Highway." Campbell composed approximately 80 gospel songs. She has been called the great song composer of the National Baptist Convention. In her leadership role with the National Baptist Convention, Campbell introduced promising young musicians such as Marian Anderson and J. Robert Bradley to the world.

AMPICO RECITAL

UNDER THE AUSPICES OF THE

MUSIC DEPARTMENT

OF THE

WOMAN'S CLUB OF TUNICA COUNTY

AT THE HOME OF

MRS. G. B. HARDY
TUNICA, MISS.
FRIDAY, OCTOBER THIRTY-FIRST

8:15 P. M.

By 1903, a catalog from the one-stop music store, E. Witzmann and Company, advertised over 350,000 pieces of sheet music in their inventory. The catalog listed pianos and sheet music published by the firm and, in addition, a full line of instruments, the Ampico piano, instrumental supplies, teaching aids, rosin for string instruments, and metronomes. At this point, Witzmann's retail store could boast selling "all things musical."

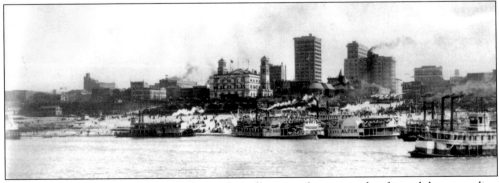

Witzmann's growing enterprise joined a number of booming businesses that formed the expanding business riverfront on the bluff of the river.

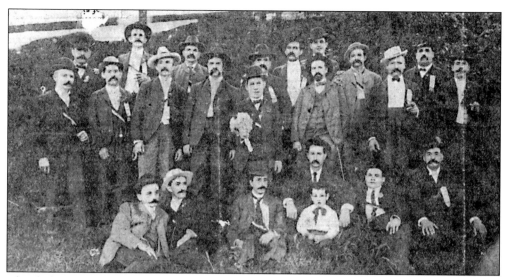

The daily newspaper announced that on the afternoon and evening of June 18, 1905, the first Southern Circuit of North American Saengerbund (pictured above) would take place at the Bijou Theater. The event brought together hundreds of male singers with orchestral accompaniment representing the cities of New Orleans, Chattanooga, Cairo, Decatur, Little Rock, and Memphis. It was directed by Prof. R. L. Telchfuss and Prof. H. Schulze. A chorus of 400 children directed by Miss L. Crenshaw was selected from the Memphis public schools to be a part of the Saengerbund event.

By the year 1908, Memphis was a unique and well-defined regional music city. Within one year, however, a new chapter in the history of music worldwide would actually begin to take shape in Memphis.

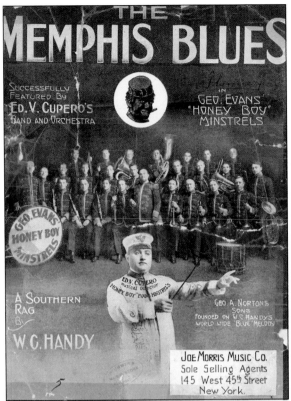

The year 1909 is a nexus point in the history of Memphis music. It was in this year that William Christopher Handy (1873–1958) wrote a campaign song for one of the most powerful political figures in the history of Memphis, mayoral candidate Edward H. Crump. The song achieved instant success and was a hit with audiences of all kinds. Handy (pictured below holding his trumpet) was a bandmaster, and with his local hit "Mr. Crump," Handy's band was in high demand. Although Handy sold his rights to "Mr. Crump" for $100 (which he regained in 1940), this song catapulted his association with the new genre of music called the blues.

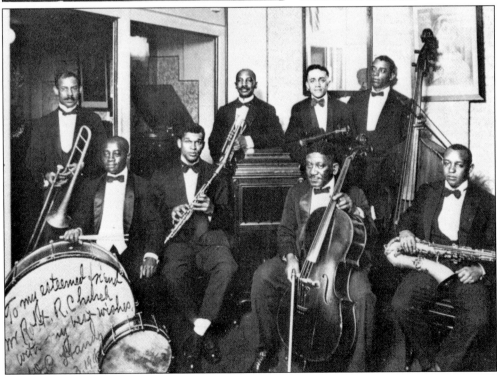

The song "Mr. Crump" was the backdrop for E. H. Crump's campaign, and it was the rave of the streets. In 1912, Handy published the song under a new title, "Memphis Blues." Two years later, Handy published "St. Louis Blues," one of the biggest of all hit songs of the 20th century. Handy was now a composer, lyricist, owner and distributor of intellectual property through sheet music, and the person that introduced the world to a new genre of popular music. Handy's music was actually a rag tune, but it ushered in the way for black popular music that was to lay the foundation for all other popular music forms of the 20th century. In 1913, Handy published "Jogo Blues," in 1915, "Joe Turner Blues," and in 1917, "Beale Street Blues."

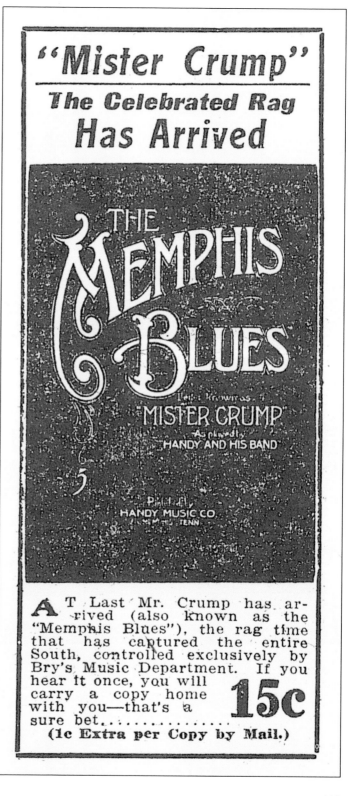

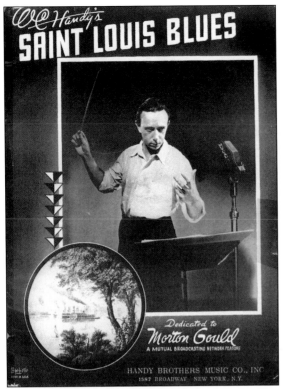

Handy was a well-trained musician who had paid his dues of advancement in the business of music. Born in Florence, Alabama, in 1873, at an early age, Handy played in a minstrel band and later was bandmaster at A&M College in Huntsville, Alabama. Handy directed his own minstrel band for Mahara's Minstrels and then toured as bandmaster and dance orchestra director from 1903 to 1908 in the Mississippi Delta region before settling in Memphis in 1908, where he continued directing bands. It was in that year he established with his business partner the Pace and Handy Music Company in Memphis. In 1918, Handy and Harry Pace took their company from Memphis to New York City, where it continues today. Handy's company achieved considerable success and marked Memphis as an early player in the business of musical intellectual property ownership and distribution.

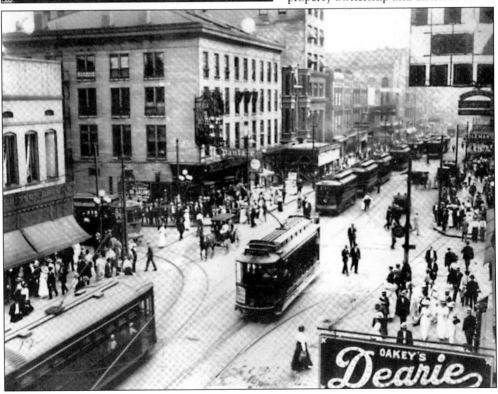

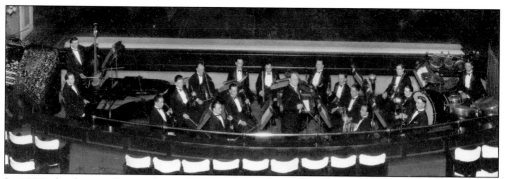

In 1909, the first professional symphony orchestra was formed in Memphis. The Philharmonic Orchestral Association disbanded that year and, combining with the members of the Philharmonic Quintette Club, formed the core of what was to become today's Memphis Symphony Orchestra. The new professional organization was directed by Jacob Bloom. At the Lyceum Theatre on January 13, 1910, the new orchestra of 45 musicians made their Memphis debut. All but eight of the players were from Memphis. Determined Memphians resolved to make symphonic orchestral music one of the cornerstones of musical culture in the city. The determined founders obtained a charter approved by the Tennessee governor and the secretary of state. A symphony society was formed, and permanent memberships were sold to raise foundational funding for the transformed organization. By 1912, the orchestra was conducted by Arthur Wallenstein, who was succeeded by Carl Metz and Arthur Nevin; in 1922, the orchestra was led by Joseph Henkel. After a lapse of a few years due to financial problems, Henkel returned as conductor. Henkel was born in Memphis and at the age of 14 went to Germany and studied violin for three years at the Boehmert Conservatory at Ponkow near Berlin. At the age of 21, Henkel returned to Memphis.

Memphis had come full-circle musically. Native Memphian Joseph Henkel had received formal training in Germany to return to Memphis to lead the city's iconic musical organization, the civic symphony orchestra. African American bandmaster and well-trained musician W. C. Handy had come to Memphis to start his song and intellectual property empire based upon his experience and entrepreneurial savvy as an itinerant musician throughout the Mississippi Delta.

By 1904, Christopher Philip Winkler, "Dean of Memphis Musicians," and his wife (left) formally retired to their summer home in Arkansas. Winkler died in 1913 while visiting his son in Fort Myers, Florida (below). His publisher and friend Emile Witzmann built the longest-running music retail store and publishing company in Memphis. Witzmann died the next year, in 1914. In an article published in the *Commercial Appeal* a few years after his death and upon the liquidation of the Witzmann company, the writer stated, "Most of the city's musical history is closely interwoven with the old firm, for Mr. Witzmann had a unique and distinctive personality which won for him friends throughout the Memphis territory." The treasurer's book of the Musician's Protective Union of Memphis, by this time the American Federation of Music Local No. 71, listed debit entry No. 142 in the year 1917, "J. G. Handwerker Death Assessment . . . [$] 152.00." The former president of the Musician's Union and founding orchestral leader John George Handwerker died in 1917. These founding patriarchs of Memphis musicians, all three German, were laid to rest within four years of each other. An era had come to an end.

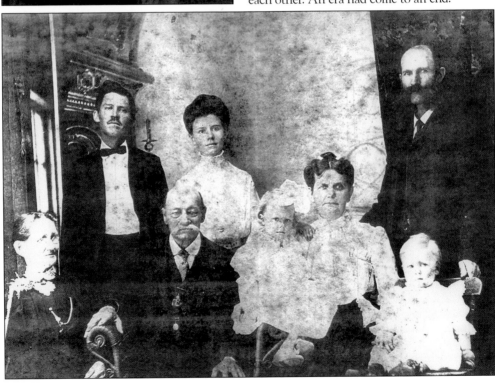

Ten

REFLECTIONS ON MEMPHIS MUSIC BEFORE THE BLUES

The impact Germans, Italians, Irish, Jews, Swiss, French, and Africans made upon all aspects of cultural life in Memphis is the very foundation on which all future musical endeavors were built in the city. The story of Memphis music is the story of a fertile area of musical migration from many countries that took hold and shape in a rapidly growing cosmopolitan city in the South in the 19th century.

The immigrants that came to Memphis held on to many of the best aspects of culture from their homeland, while still assimilating into the customs, language, and industry of their new home. They were not immune from the politics of the Civil War or the devastation of the yellow fever. Immigrants fought and died and immigrants contracted yellow fever and died. Still the survivors remained and continued to grow, prosper, and assimilate in the area.

A growing, affluent population with discretionary leisure time was present in Memphis in the 1880s and 1890s. These elements are necessary for the arts to flourish, and they combined with a rise in amateur music making and fine art appreciation by the inhabitants of the city in the late 19th century. These elements were fueled by optimism and renewed hope in the wake of the yellow fever epidemics of the 1870s. A cultural catharsis took shape as Germans led the city in music making and celebration. Retail music activity and music publishing was dominated by German merchants, the foremost of which was E. Witzmann and Company.

In Memphis today, the cultural signs of the early German population can be seen in the vibrant arts organizations that trace their beginnings back to German efforts in the 19th century. Some still remember the names Witzmann, Bruch, Handwerker, Winkler, and later Reinhardt (whose store is pictured below), Steuterman, and Bohlmann, but it is the performing ensembles, schools, churches, and cultural societies that remain as a result of their legacy and form the core of the city's finest music today. These musical organizations include the Memphis Symphony Orchestra (above), Opera Memphis, the Rhodes College Department of Music, the music at Christian Brothers University and the University of Memphis, the venerable Beethoven Club, numerous choral organizations of the city, strong church music programs started by Germans and other immigrants, and the itinerant touring organizations that came through Memphis, which until only a few years ago still included the Metropolitan Opera. All of the societies save the Beethoven Club have vanished, but their offspring remain.

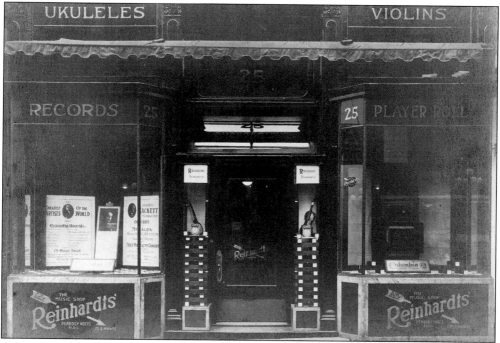

Today members of both Trinity Lutheran Church and St. Mary's Catholic Church relive and note with pride their German heritage through the current Germania Club, the continuation of a version of the Mai Feste, and the annual German Christmas Service. The colleges and universities of Memphis continue to offer the highest education in music ranging from blues to classical styles. Pictured above are B. B. King and Robert Shaw at a Rhodes College graduation ceremony.

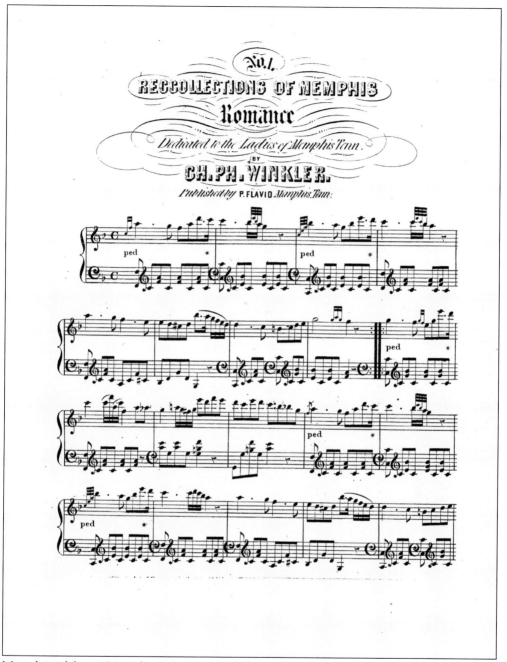

Memphis celebrates Memphis in May, a month-long celebration of the city's culture and heritage. It was Germans who began this celebration in the form of their Mai Feste in the 19th century. While the German societies were restricted to German members, their cultural activities were offered to the public. They shared Mai Feste with the entire community throughout the second half of the 19th century. Mai Feste, and the current Memphis in May, made a contribution to the city that civil rights leaders and all enlightened leaders today work hard to achieve—the bringing together of people of all nationalities, religions, and ethnic origins in a common celebration of shared life in community.

Ellis Auditorium in downtown Memphis was a primary concert location for major music events throughout most of the 20th century. This concert venue was dedicated in 1924. The building was torn down and is today replaced at the same location by the Cannon Center for the Performing Arts. The organ from the original building was moved to Bartlett United Methodist Church.

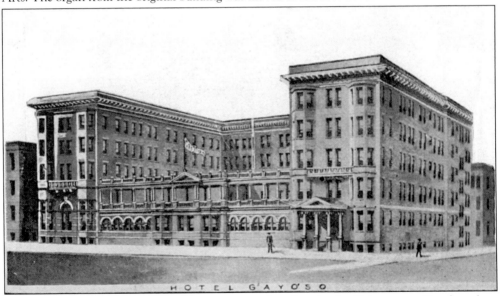

Hotel Gayoso was host to bands and many society functions in the 19th century. Bands such as those pictured on the cover of *Memphis Music: Before the Blues* played in the ballroom of this Front Street hotel. Today a condominium complex built to resemble the original hotel structure is located on the same site.

Christopher Winkler reflected in 1890, "When I came to the city, in 1855, the prevailing style of music was 'Oh! Susanna, Don't You Cry,' 'Old Dog Tray,' and 'My Old Kentucky Home.'" Winkler arrived in a city that only knew plantation songs such as those he listed by Stephen Foster, popularized by traveling minstrel troupes such as Christy's Minstrels. By the time of Winkler's writing in 1890, concert repertoire in Memphis included names such as Schubert, Boehm, Liszt, and Wagner. Homes were host to pianos manufactured by Knabe and Steinway, thanks to the retail efforts of Witzmann, Hollenberg, and Houck. Memphis had a vibrant musical culture in which to welcome a well-trained W. C. Handy at the birth of the new century.

Music publishing companies such as those operated by Katzenbach, Flavio, and Witzmann disappeared in the 20th century. Christopher Philip Winkler remains the most prolific published composer in the history of Memphis with nearly 1,000 publications printed in his lifetime.

In the 20th century, new concert venues were built such as the auditorium of the Goodwyn Institute. The Goodwyn Institute building was built in 1907 and its auditorium played host to chamber concerts featuring the works of Mozart, Mendelssohn, and Beethoven.

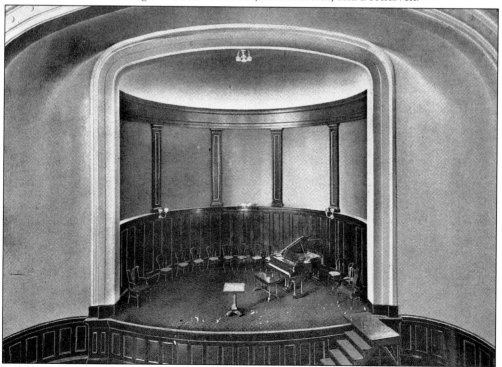

BIBLIOGRAPHY
PRIMARY SOURCES

Bruch, Donald (relative of George Frederick Bruch). Personal oral interviews with author.

Certificate of Affiliation for the Memphis Chapter of the American Federation of Musicians. February 6, 1898.

Commercial Appeal. November 8, 1885; September 30, 1894; December 23, 1894; October 13, 1895; December 22, 1895; March 31, 1896; April 5, 1896; May 17, 1896; August 31, 1896; February 23, 1897; April 2, 1899; November 14, 1909; March 23, 1913; November 23, 1914; April 9, 1921; March 13, 1948; April 7, 1948.

Daily Appeal. October 30, 1859; November 11, 1859; January 1, 1861.

Daily Avalanche. February 17, 1888.

Davis, James D. *The Old Times Paper,* 1810–1873, Memphis, TN.

E. Witzmann and Company. *Musical Novelties Catalog, 1896.* Murfreesboro, TN: Middle Tennessee State University Center for Popular Music.

Handwerker, Dan (relative of John George Handwerker). Personal oral interviews with author.

Hugh Higbee Hun Theater Collection. Memphis and Shelby County Room of the Memphis Public Library.

Keating, John. *History of the City of Memphis and Shelby County, Tennessee.* Vol. 1. Syracuse, New York: D. Mason and Company, 1888.

Masonic Sketch of Professor C. P. Winkler. Fort Myers Press, January 26, 1911, Fort Myers, FL.

Memphis Appeal-Avalanche. December 24, 1890; April 16, 1892; October 18, 1892; March 26, 1893.

Memphis Argus. September 13, 1865.

Memphis Bulletin. December 11, 1864.

Memphis City Directory. 1880–1900. Elmwood Cemetery Archives.

Memphis Daily Commercial. July 21, 1890; July 22, 1890.

Musician's Protective Union of Memphis, Tennessee. Treasurer's Book. 1895–1927. Memphis Federation of Musicians, Local No. 71, American Federation of Musicians.

U.S. Bureau of the Census. Shelby County, Tennessee, 1820–1900.

Winkler, David (relative of Christopher Philip Winkler). Personal oral interviews with author.

Witzmann-Gamble Papers. Memphis and Shelby County Room of the Memphis Public Library.

SECONDARY SOURCES

Anglin, Daniel. "The 'Dean of Memphis Musicians': The Life and Work of Christopher Philip Winkler, 1824–1913." *Journal of the Rhodes Institute for Regional Studies*, 2003.

Bond, Beverly and Janann Sherman. *Memphis in Black and White*. Charleston, SC: Arcadia Publishing, 2003.

Brewer, Roy C. *Professional Musicians in Memphis (1900–1950): A Tradition of Compromise*. Unpublished Ph.D. dissertation, University of Memphis, 1996.

Bristow, Eugene Kerr. *Look out for Saturday Night: A Social History of Professional Variety Theater in Memphis, Tennessee, 1859–1860*. Unpublished Ph.D. dissertation, University of Iowa, August 1956.

Campbell, JoBeth, "Everything Musical: E. Witzmann and Company and Music in Memphis Society." *Journal of the Rhodes Institute for Regional Studies*, 2006.

Capers, Gerald. *The Biography of a River Town*. Memphis: Burke's Book Store Reprint, 1966.

Church, Roberta and Ronald Walter, Charles W. Crawford, ed. *Nineteenth Century Memphis Families of Color 1850–1900*. Memphis: Murdock Printing Company, 1987.

Cooper, Michael L. *Slave Spirituals and the Jubilee Singers*. New York: Houghton Mifflin Company, 2001.

Cordell, Gina and Patrick O'Daniel. *Historic Photos of Memphis*. Nashville: Turner Publishing Company, 2006.

Faulkner, Seldon. *The New Memphis Theater of Memphis, Tennessee, From 1859–1880*. Unpublished Ph.D. dissertation, University of Iowa, June 1957.

Faust, Albert B. *The German Element in the United States*. 2 Vols. Boston: Houghton Mifflin Company, 1909.

Hine, Darlene Clark, ed. *Black Women in America: An Historical Encyclopedia*. Vol. 1. Brooklyn: Carlson Publishing Company, 1993.

Houston, Ruth. "A Dream Come True: Papa Tuthill and Memphis Music." *Journal of the Rhodes Institute for Regional Studies*, 2005.

Lee, George W. *Beale Street: Where the Blues Began*. New York: Robert O. Ballou, 1934.

Loesser, Arthur. *Men, Women, and Pianos*. New York: Simon and Schuster, 1954.

Magness, Perre. *Elmwood 2002: In the Shadows of the Elms*. Memphis: Elmwood Cemetery, 2001.

Myracle, Kay Ferree. *Music in Memphis, 1880–1900*. Unpublished master's thesis, Memphis State University, 1975.

Rauchle, Bob Cyrus. *Social and Cultural Contributions of the German Population in Memphis, Tennessee, 1848–1880*. Unpublished master's thesis, University of Tennessee, June 1964.

Ringel, Judy G. *Children of Israel: The Story of Temple Israel*. Memphis: Temple Israel Books, 2004.

Ritter, Charles Clifford. *The Theatre in Memphis, Tennessee, from its Beginning to 1859*. Unpublished Ph.D. dissertation, University of Iowa, June 1956.

Roell, Craig H. *The Piano in America, 1890–1940*. Chapel Hill: University of North Carolina Press, 1989.

Southern, Eileen. *The Music of Black Americans: A History*. 3rd ed. New York: W. W. Norton and Company, 1997.

INDEX

Discover Thousands of Local History Books Featuring Millions of Vintage Images

Arcadia Publishing, the leading local history publisher in the United States, is committed to making history accessible and meaningful through publishing books that celebrate and preserve the heritage of America's people and places.

Find more books like this at
www.arcadiapublishing.com

Search for your hometown history, your old stomping grounds, and even your favorite sports team.

Consistent with our mission to preserve history on a local level, this book was printed in South Carolina on American-made paper and manufactured entirely in the United States. Products carrying the accredited Forest Stewardship Council (FSC) label are printed on 100 percent FSC-certified paper.

MADE IN THE